Art OF OUR TIME

Art OF OUR TIME

SELECTIONS FROM THE | ULRICH MUSEUM OF ART
WICHITA STATE UNIVERSITY

Patricia McDonnell AND *Emily Stamey*

WITH CONTRIBUTIONS BY

Toby Kamps, Laura Moriarty,

Antonya Nelson, Timothy R. Rodgers,

AND *Robert Silberman*

PHOTO-ESSAY BY *Larry Schwarm*

Ulrich Museum of Art | Wichita State University

in association with the University of Washington Press

This book is published in conjunction with the exhibition *Art of Our Time: Selections from the Ulrich Museum of Art, Wichita State University*

April 24–August 8, 2010.

Edwin A. Ulrich Museum of Art
Wichita State University
1845 Fairmount Street
Wichita, KS 67260-0046
www.ulrich.wichita.edu

University of Washington Press
P. O. Box 50096
Seattle, WA 98145-5096
www.washington.edu/uwpress

Book design: Patrick Dooley, Lawrence, Kansas

Assistant manuscript editor: Susan C. Jones, Minneapolis

Photographers: Larry Schwarm and Jim Meyer for the Ulrich Museum of Art, except work by Zhang Huan (courtesy of the artist)

Printing and binding: Greystone Graphics, Kansas City, Kansas

This book was typeset in Adobe Garamond Pro, designed by Robert Slimbach (based on the roman typefaces of Claude Garamond and italic typefaces of Robert Granjon), and Gill Sans, designed by Eric Gill.

Library of Congress Cataloging-in-Publication Data

Edwin A. Ulrich Museum of Art.

Art of our time: selections from the Ulrich Museum of Art, Wichita State University / Patricia McDonnell and Emily Stamey; with Toby Kamps . . . [et al.]; photographic essay by Larry Schwarm. – 1st ed.

 p. cm.

Published on the occasion of an exhibition held at the Ulrich Museum of Art, Wichita State University, Apr. 24–Aug. 8, 2010.

ISBN 978-0-295-99024-8 (cloth) – ISBN 978-0-295-99025-5 (paper)
1. Art, Modern – 20th century – Exhibitions. 2. Art, Modern – 21st century – Exhibitions. 3. Art – Kansas – Wichita – Exhibitions. 4. Edwin A. Ulrich Museum of Art – Exhibitions. I. McDonnell, Patricia, 1956 – II. Stamey, Emily. III. Kamps, Toby. IV. Schwarm, Larry, 1944– V. Title. VI. Title: Selections from the Ulrich Museum of Art, Wichita State University.
N6490.E36 2010
709.04'007478186 – dc22

 2009051477

Front cover: Joan Miró, *Personnages Oiseaux* (Bird People), 1977–78 (cat. no. 16)

Back cover: Tom Otterness, *Millipede*, 2008 (cat. no. 45)

This exhibition and book have been made possible through the generous support of Emprise Bank and the National Endowment for the Arts. Additional sponsors include the Joan S. Beren Foundation, Edward and Helen Healy, Harry Pollak, and Richard S. Smith and Sondra M. Langel. Support has also been provided by Jon and Kelly Callen, Mike and Dee Michaelis, Jayne S. Milburn, Christine F. Paulsen-Polk, and the Wichita State University Office of the Provost and Vice President for Academic Affairs and Research.

Contents

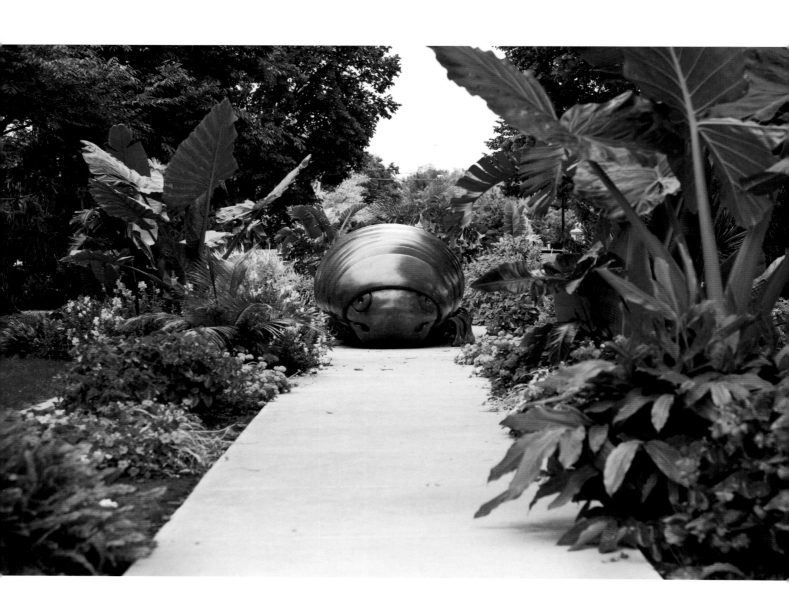

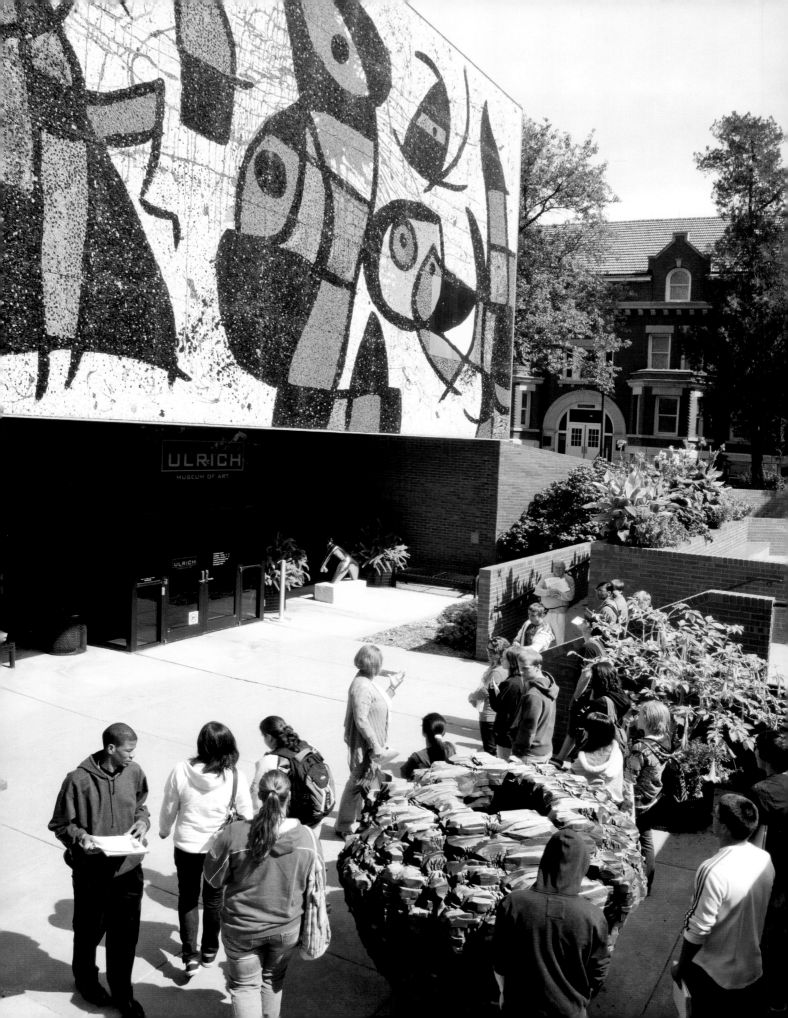

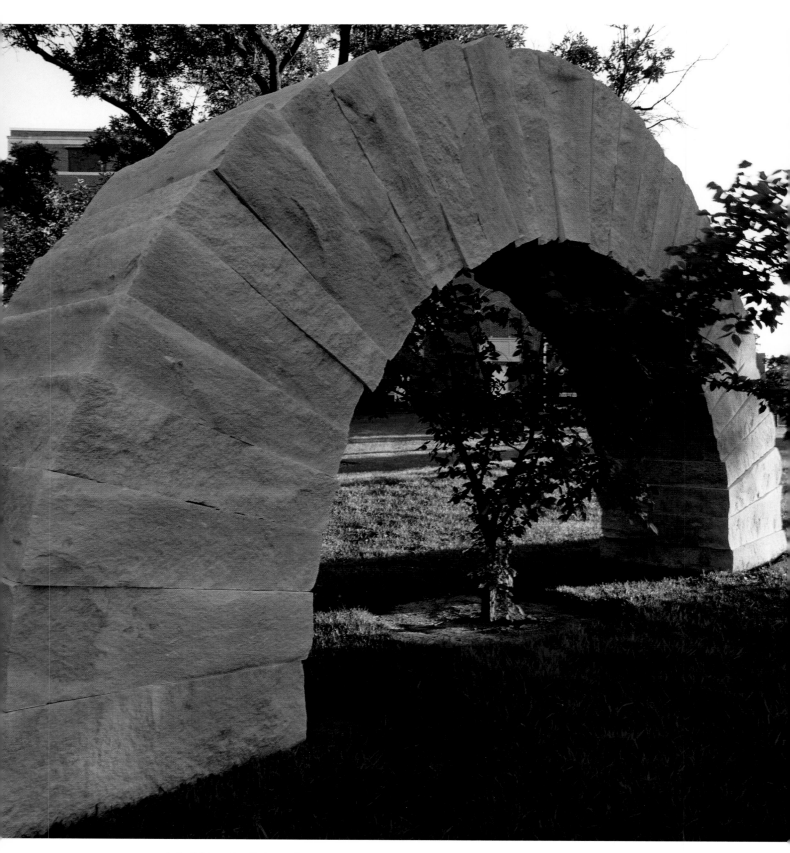

Andy Goldsworthy, *Wichita Arch*, 2004. Cat. 49

Preface

Art derives a considerable part of its beneficial exercise from flying in the face of presumption.

Henry James

BECAUSE MY WIFE, SHIRLEY, AND I LIVE ON CAMPUS, we have a singular opportunity to see works from the Edwin A. Ulrich Museum of Art. In fact, many paintings from its collection are displayed in our home, where Wichita State University guests can admire and enjoy them and appreciate how the Ulrich enriches our daily lives. Several works are exhibited in campus buildings and senior administrative offices as well.

On our frequent walks around campus, Shirley and I are also able to enjoy the Martin H. Bush Outdoor Sculpture Collection, which the magazine *Public Art Review* recognized in 2006 as one of the ten best on a university campus in the United States. That collection features seventy-seven works by such world-renowned artists as Fernando Botero, Andy Goldsworthy, Barbara Hepworth, Luis Alfonso Jimenez, Joan Miró, Louise Nevelson, and Wichita's own Tom Otterness. We are often told how beautiful the WSU campus is, and the Outdoor Sculpture Collection certainly contributes significantly to that beauty.

Since its founding in 1974, the museum has assembled a collection that now numbers some sixty-three hundred works, many of which are internationally recognized and prized. Thanks to a talented and dedicated staff, the enthusiastic service and support of countless volunteers, and the ongoing financial generosity of students, faculty, and friends, the Ulrich Museum of Art is an undeniable treasure for our university, for Wichita, and for Kansas.

With its primary focus on modern and contemporary art, the museum succeeds brilliantly in presenting works that both challenge presumption and reward active engagement. I congratulate and applaud Dr. Patricia McDonnell and her staff for organizing this wonderful exhibition and catalogue, both of which showcase the Ulrich and its distinguished holdings. Thoughtfully conceived and executed, *Art of Our Time* is a masterful presentation befitting an outstanding institution.

Donald Beggs
President
Wichita State University

Acknowledgments

The thankful receiver bears a plentiful harvest.

William Blake

EVER SINCE THE EDWIN A. ULRICH MUSEUM OF ART OPENED ITS DOORS, IN 1974, a spirit of altruism has prompted numerous patrons to donate artworks to Wichita State University and this institution. Their many individual gifts have helped produce a collection of considerable stature. So for *Art of Our Time*, which celebrates the finest gems in the collection, it is fitting to acknowledge first those donors as well as the benefactors who have contributed works of art and have created collection-endowment funds over the years. Together they have seeded a plentiful harvest indeed, for which the university and museum are enduringly grateful.

The members of the Ulrich Museum of Art Advisory Board were unstinting in their support of *Art of Our Time*. They gave generously as project donors and pressed the staff to strive for excellence in every detail.

The university's leaders worked enthusiastically on behalf of *Art of Our Time*. President Donald Beggs and his wife, Shirley, have been exceptional friends to the museum and unequivocal proponents of the exhibition and the book. Dr. Gary Miller, Provost and Vice President, Academic Affairs and Research; Dr. Martha Shawver, Senior Associate Provost, Academic Affairs and Research; and Dr. Rodney Miller, Dean, College of Fine Arts, all aided the project and deserve our heartfelt thanks. Dr. Elizabeth King, President and Chief Executive Officer, Wichita State University Foundation, grasped the importance of this undertaking from the start and shared the resources of her office and organization. Diana Gordon, Director of Development for Fine Arts, was an invaluable partner in garnering support for and advancing the cause of the exhibition and publication.

Toby Kamps, Timothy R. Rodgers, Robert Silberman, and Emily Stamey contributed brief essays that illuminate the context and meaning of the artworks they concentrated upon. Laura Moriarty and Antonya Nelson wrote creative interpretations of the works that were their focus, thereby enriching both our understanding and our enjoyment. And photographer Larry Schwarm produced a series of images that vividly demonstrate the ways great sculpture enhances the outdoor spaces of this campus.

We are grateful to manuscript editor Phil Freshman and graphic designer Patrick Dooley for their roles in producing this book. Both helped us shape its language and look, and they worked many improvements through their alertness to matters large and small. We also thank Greystone Graphics for an exquisite job of printing and binding.

Everyone on the Ulrich Museum staff contributed imagination, skill, and countless hours to this exhibition and publication. Linda Doll ably managed the contracts, bills, and staffing. Angela Lentino coordinated the hectic front desk and assisted in myriad tasks. Aimee Geist, in her role as our readers' advocate, was among the first to review

the manuscript for this book, and she developed exciting programs to expand public understanding of the art even further. Teresa Veazey conceived and oversaw all marketing connections to the project. Kevin Mullins, aided by the striking designs of the noted Wichita architect Dean Bradley, created an inventive and compelling exhibition installation. Mark Janzen ably handled image-reproduction permissions, new artwork framing, and object-records management.

Emily Stamey helped me develop and direct this project and, in the process, did much of the heavy lifting. As exhibition curator, she selected the artworks, shepherded the contributors, and performed a seemingly endless series of related tasks. In addition, she wrote a number of catalogue entries, applying her characteristic thoroughness and insight to each one. She is due a lion's share of praise for the quality of this volume.

Finally, we dedicate this landmark exhibition and publication to all those in the wsu and Wichita arts communities who visit our galleries, attend our programs and parties, and admire our on-campus sculpture. In the end, the collection exists to engage them in the kinds of experiences that can occur when individuals encounter and deeply consider a work of art. Such encounters can be transformative. At the Ulrich, we extend thanks to the network of people who are intrigued and captivated by the art of our time.

Patricia McDonnell
Director

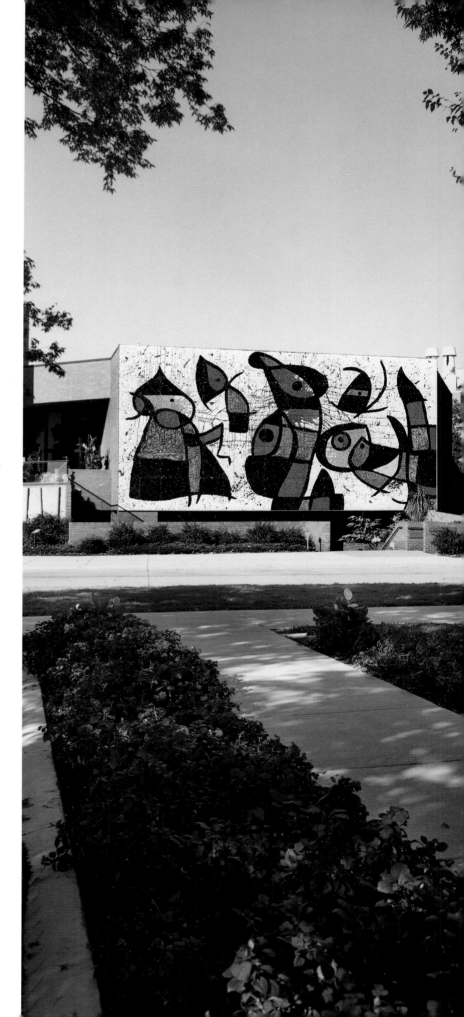

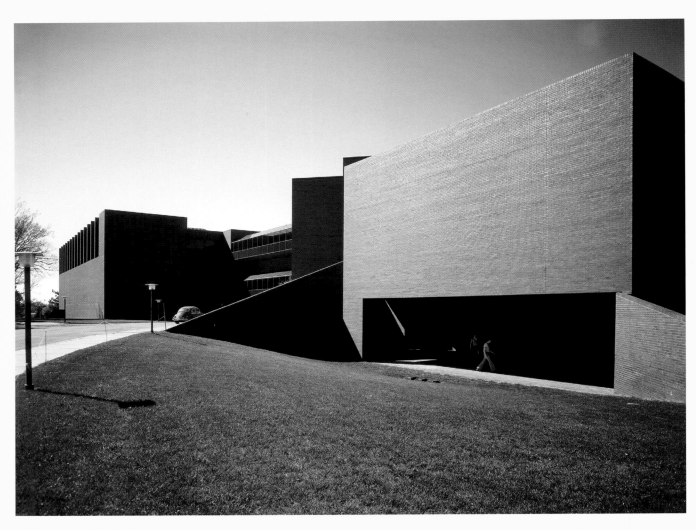

Ulrich Museum of Art facade, ca. 1977.

Art for All in Wichita

A Brief History of the Ulrich Museum of Art

Patricia McDonnell

FOUNDING ANY ORGANIZATION REQUIRES IMAGINATION, TENACITY, AND GRIT. Establishing a university art museum demands all this and more, because forces of the status quo tend to question the wisdom of dedicating financial resources to an entity that will not generate tuition income. Wichita State University President Clark Ahlberg appreciated that a great university educates its students in myriad ways and that exposure to the fine arts enhances the cultural experience of an entire campus community. A native Wichitan educated at the University of Wichita (which has since 1964 been Wichita State University) and Syracuse University, Ahlberg served as president from 1968 to 1983. During his tenure, he oversaw unprecedented institutional growth, including extensive campus beautification and the creation of the Edwin A. Ulrich Museum of Art.

President Ahlberg believed that a superior university should be ever mindful of the thriving city surrounding it. In 1977 he articulated his commitment to this belief: "We have an obligation to reach as many people as possible and to do it with the highest standards – in this case, the highest artistic standards – if we are to properly serve this urban area."[1] To execute his plan to make art an integral part of university life, Ahlberg recruited a trusted colleague, Dr. Martin H. Bush, formerly of Syracuse University. In 1971 Bush began his twenty-year tenure as vice president of Academic Resources, during which he guided the establishment of a museum and collection that today enjoy a national reputation.

Bush arrived at a propitious time in campus development. Mrs. Eva H. McKnight had bequeathed a considerable sum for the construction of a fine arts building; in 1967 funds from the McKnight trust were released for the project. This generous gift, along with state and federal support, enabled the university to begin planning a facility that would house classrooms for art and art-history instruction and gallery spaces for a museum. A young African American architect named Charles McAfee – a Wichita native who maintained a strong regional practice – was commissioned to design this multipurpose edifice, which he conceived as comprising a pair of three-story-tall sections linked by skyways. Then and now, the distinctively modernist brick structure announces its artistic purpose, its creative design distinguishing it from the buildings that surround it. Among those who contributed their expertise to the development of the McKnight Art Center were longtime members of the department of art and art history, including David Bernard, Clark Britton, Mary Sue Foster, Mira Merriman, and John Simoni, all ably led by department head Robert Kiskadden.

While conferring with university planners about the new structure, Martin Bush, in his capacity as museum director, was also cultivating relationships with collectors who might choose to donate art to the fledgling institution. The New York businessman Edwin A. Ulrich, who had made his fortune in oil, was so impressed with Bush's initiative that he donated his substantial collection, which featured more than three hundred works by the late-nineteenth- and

Left to right: Bob Howse, Mrs. Rowena Ahlberg, and Wichita State University President Clark Ahlberg at an Ulrich Museum exhibition opening, 1976.

Edwin A. Ulrich (right) and museum curator Gary Hood tour the Ulrich-organized exhibition *Frederick Waugh: The Development of Style*, fall 1986.

early-twentieth-century American painter Frederick Judd Waugh; he also set up an endowment for its care. In honor of this donor's exceptional generosity, the university named the new facility the Edwin A. Ulrich Museum of Art. Great fanfare and celebrations marked its opening – along with the rest of the McKnight Art Center – on December 7, 1974.

The building was just a facet of the ambitious plans Ahlberg and Bush had for the museum. A broad expanse of the McKnight Art Center's southern-exterior wall was designed specifically to accommodate a massive mural. Determined

to convey the university's commitment to both aesthetic and academic excellence, the two men decided to approach the most significant artists of their day. Pablo Picasso was the first whom Martin Bush asked to design the mural.[2] Ultimately, he persuaded another acclaimed Spanish artist, Joan Miró, to undertake the project. By 1970, Miró had created other large-scale murals, most notably in Cambridge, Massachusetts, Barcelona, Osaka, Paris, and New York. Unlike those earlier works, which were executed in ceramic, the Wichita State University project allowed the artist to design a twenty-eight-by-fifty-two-foot mural in glass and marble (cat. no. 16). A specialized stained-glass studio in Chartres, France, fabricated the work using glass from the Venetian isle of Murano. The Boeing aircraft-manufacturing company supplied the design for the steel frame to which the eighty five-by-three-foot panels were attached. When the completed work, *Personnages Oiseaux* (Bird People), was dedicated on October 31, 1978, *Time* magazine art critic and cultural historian Robert Hughes spoke at the ceremony. Since then, the Miró mural has become a treasured symbol of the museum, the university, and Wichita itself. Generously, the artist did not take a fee for his design, receiving a nominal payment only for the painting that served as a prototype for the mural.

Thanks to Martin Bush and his ability to attract nationally significant exhibitions and artists to Wichita, the Ulrich achieved a certain "star quality" early on. By focusing on the work of living artists, it distinguished itself from the other art institutions in the city – the Wichita Art Museum and Wichita Center for the Arts. Such artistic luminaries as Isabel Bishop, Alice Neel, Louise Nevelson, and Kansas native Gordon Parks visited the campus in conjunction with exhibitions at the museum. Henry Moore met with WSU decision-makers to select the site for his sculpture, *Reclining Figure (Hand)* (1979), which was installed in 1982. And when the Ulrich exhibited the works of Duane Hanson in October 1976, more than thirty thousand visitors enjoyed the artist's startlingly lifelike sculptures.[3]

During the museum's early years, Bush also was aggressively building its collection. In 1972, just a year after arriving in Wichita, he secured the sculptures *Happy Mother* (1958) by Chaim Gross and *Two Lines Oblique Down, Variation III* (1970) by George Rickey. And before the museum had

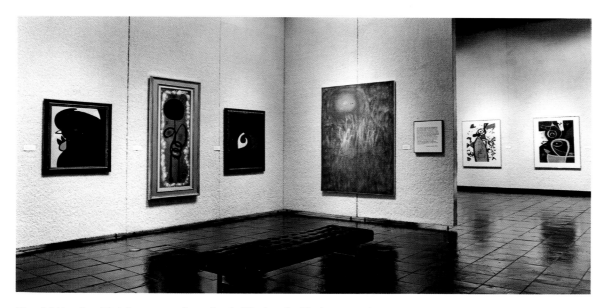

The exhibition *Joan Miró: Paintings* was featured at the Ulrich in the fall of 1978. Miró's museum-commissioned mural, *Personnages Oiseaux*, was dedicated on October 31.

even opened its doors, in 1974, Bush secured paintings by Frank Duveneck, Emil Nolde, and Benny Andrews – all featured in this book (cat. nos. 1, 9, and 38, respectively). The collection catalogue published in 1980 attests to Bush's remarkable ability to acquire thousands of works of art, many of truly exceptional quality.[4] Today, the Ulrich's holdings exceed sixty-three hundred objects.

The museum acquired another notable collection during its formative years: In 1971 the daughter and son-in-law of the prominent American sculptor Charles Grafly donated the contents of the artist's studio and his personal papers as well as funds to establish an endowment for collection care. Grafly taught from 1892 to 1929 at the Pennsylvania Academy of the Fine Arts in Philadelphia and received notable commissions and competitive awards over the course of his career. In 2005 the Ulrich opened the Grafly Garden – featuring a colonnade interspersed with foliage and adorned with six of his sculptures – in order to make this feature of the collection more accessible to the public.

Martin Bush left the Ulrich in 1991 to head the ACA Galleries in New York. His successor, Dr. Donald Knaub, led the museum from 1992 until 1999. He oversaw a renovation of the McKnight Art Center that increased gallery

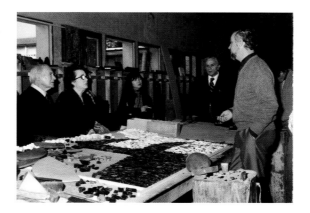

Left to right: Joan Miró, two unidentified women, art dealer Pierre Matisse, and stained-glass artisan Jacques Loire discuss *Personnages Oiseaux* at Ateliers Loire, ca. 1977.

space and enabled the facility to comply with Americans with Disabilities Act accessibility guidelines, established in the early 1990s. Dr. David Butler, who became director in 2000, successfully undertook the process of obtaining American Association of Museums accreditation for the Ulrich; it was granted in 2005. He also directed a deaccessioning project, working closely with his staff to assess the museum's holdings. As a result of their conscientious review and judicious pruning, they were better able to sharpen the focus of the then-quarter-century-old collection. Also

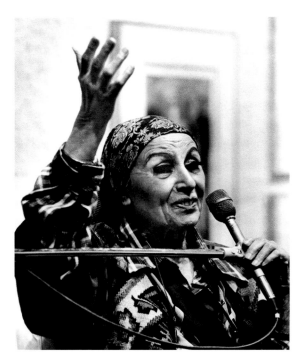

Sculptor Louise Nevelson speaks to Ulrich visitors, fall 1978

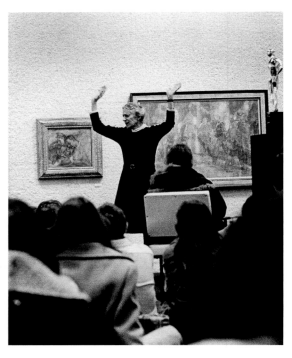

Painter Isabel Bishop speaks to Ulrich visitors in the galleries where a retrospective of her work was on view, winter 1975.

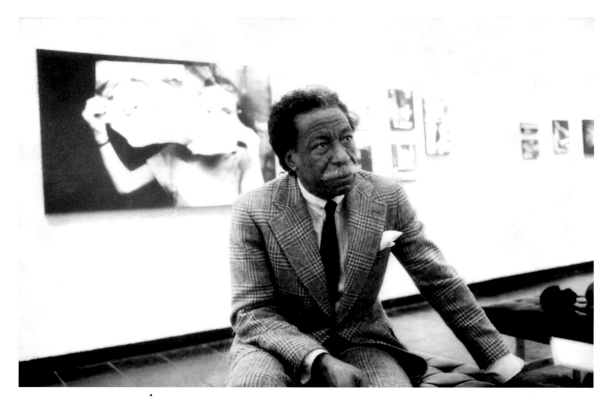

Photographer Gordon Parks visits the galleries where a retrospective of his work was on view, February 1978.

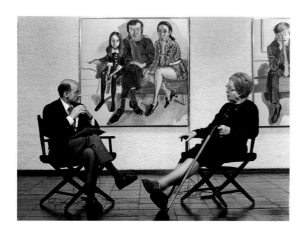

Founding Director Martin H. Bush and painter Alice Neel converse in the galleries where the exhibition *Alice Neel: Paintings* was on view, spring 1978.

during Butler's tenure, the museum acquired two striking public sculptures: *Wichita Arch* (cat. no. 49) by the British artist Andy Goldsworthy (in 2004) and *Millipede* (cat. no. 45) by the Wichita native Tom Otterness (in 2008). I succeeded Butler early in 2007. This book and the nationally touring exhibition it accompanies comprise a significant project in the early phase of my directorship.

A key element of President Clark Ahlberg's master plan for an enhanced university environment in the 1970s was the presence of major works of art situated outdoors throughout the 330-acre campus. His vice president of Academic Resources wholeheartedly agreed, and today the Martin H. Bush Outdoor Sculpture Collection at Wichita State University boasts seventy-seven monumental works by such internationally eminent artists as Arman, Fernando Botero, Barbara Hepworth, Luis Alfonso Jimenez (cat. no. 42), and Claes Oldenburg (cat. no. 37). In 2002 a foresighted and generous anonymous donor created an endowment for the maintenance of campus sculptures. And in 2006, the journal *Public Art Review* ranked the Outdoor Sculpture Collection among the ten best on an American university campus.[5]

Works of public art have long been sources of pride for the university, whose students both appreciate and contribute to the success of this acclaimed museum program. By voting to allocate a portion of their Student Government Association funds to help purchase the Joan Miró mural in

1978 and Robert Indiana's *LOVE* sculpture (cat. no. 34) in 1980, they demonstrated their commitment to WSU's outstanding art museum and its Outdoor Sculpture Collection. Most recently, student contributions helped raise $150,000 toward the purchase of Otterness's twenty-five-foot-long *Millipede*. Installed on the Ulrich's front lawn, it has figured in numerous graduation photographs that capture students atop of and embracing the whimsical bronze insect.

Nearly forty years ago, President Ahlberg formulated his vision for an ambitious fine arts initiative that would enrich both the campus and the surrounding community. Today, the Ulrich continues to pursue Ahlberg's goals by offering diverse audiences a range of exhibitions and programs. Striving to capture the interest and imagination of south-central Kansas museum-goers, it operates as a dynamic gathering place, where visitors have come to expect stimulating experiences that challenge their assumptions and expand their knowledge as they view artworks in the galleries and outdoors, listen to lectures, watch performances, or socialize with friends. Indeed, every facet of the Edwin A. Ulrich Museum of Art is designed, in the words of its recently minted official mission statement, to "expand human experience through encounters with the art of our time."

1. Ahlberg quoted in Devin Brogan, "Art in Wichita: Instruction, Collection, and Innovation" (master's thesis, Wichita State University, 2006), 73.

2. Ibid., 81.

3. Martin H. Bush, "Serving the People: The Edwin A. Ulrich Museum of Art at Wichita State University," *Kansas Quarterly* 9, no. 4 (Fall 1977): 37.

4. Martin H. Bush, introduction to *Edwin A. Ulrich Museum of Art, Wichita State University* (Wichita: Edwin A. Ulrich Museum of Art, Wichita State University, 1980).

5. "Big Ten: Where Are the Best Art on Campus Collections in America?" *Public Art Review* 17, no. 2 (Spring–Summer 2006): 24–25.

Selections from the Ulrich Museum of Art

Notes to the Reader:

For the artworks profiled in this section, dimensions are given in inches. Height precedes width. Depth, where applicable, follows width.

For works on paper, both sheet and image dimensions are provided where the two differ. In cases where the image fills the sheet, one dimension is given.

For sculptures, design and fabrication dates are given in cases where the two differ.

1 *Portrait of a Lady*
(Elizabeth Boott Duveneck)
ca. 1879–88
Oil on canvas, 24 x 19 3/4 in.
Gift of Mr. and Mrs. Ralph Spencer, 1972.0049

PRETTY, YES? EVEN BEAUTIFUL? THE PAINTING, OF COURSE. BUT THE WOMAN, TOO? Thank you. I'm not sure it's a good likeness, though I mean no criticism of the artist's skill. I would have gone about it differently. I just look so healthy, so young. Maybe that's how I appeared at the time, what my husband saw as he gazed at me with loving eyes. At the time of the sitting, I was feeling fine, maybe just a little tired. Two years later, I would be dead – my painter a widower, my baby motherless.

My own mother died when I was an infant. I might have considered it a warning.

But how would I guess my own fate? Pneumonia, coming on the heels of marriage and maternity. It was a common enough death at the time. It could have happened to anyone, even in our privileged class. That it found me might have been just coincidence. But everyone knew I was tired. I was tired from caring for a teething baby, an aging father, and my virtuoso spouse. We went to Paris so he would paint, and maybe this was my undoing. For, as I hope you know, I was a painter, too. Or I had been, before I was a mother. A woman painter. It was agreed that I had a real talent with watercolor – nurtured, from the very beginning, by my father's devotion and wealth. I was never a virtuoso. Virtuosa. But I might have been.

This "might" is what kills me. What killed me.

Or maybe it was just my lungs.

My father was against the marriage from the start. It's not that he didn't like Frank. On the contrary, he liked him very much. He bought Frank's paintings and paid him to teach me, because, for me, he would have only the very best. But he didn't want me to fall in love, to marry the tutor, to marry so far beneath me. Socially, he meant. Frank had no money, no connections. Artistically, Frank was my better. Artistically, I was marrying up. For all my father's protectiveness, I don't think he understood that this was where the real danger lay.

In the beginning, those glorious days in Italy, we both were painters, husband and wife. I was happy. I painted a barefoot mother. Then I became one myself. I was gripped by that love, all that new need, and my painting came to an end.

Yet I am not so full of regret. In my short life, I lived fully. I was loved. I was a mother. And I was an artist. Just not all at the same time. My portrait of a child hangs in a museum, and I gave birth to a child as well. How many can say that? In my day, not many. In that way, I got to live twice.

And yet today, in museums, you are more likely to see me, my likeness, than what I thought or saw. I am more famous as a subject: a well-loved and departed wife, immortalized in paint and in sculpture, an alabaster tomb.

Laura Moriarty

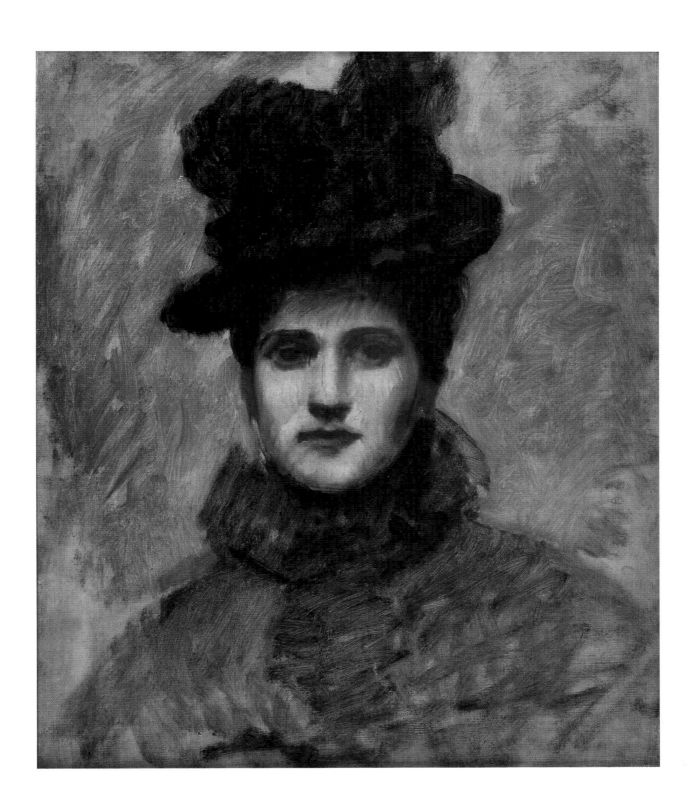

BARNACLED ROCKS IS A FINE EXAMPLE OF EARLY-TWENTIETH-CENTURY CONNECTICUT IMPRESSIONISM AS REALIZED BY THE DANISH AMERICAN ARTIST EMIL CARLSEN. Beginning in the late 1880s, Connecticut's rural charms and rugged seacoast attracted New York artists, who established colonies in Old Lyme and in the Cos Cob neighborhood of Greenwich. They appreciated the proximity of those communities to Manhattan, site of their urban studios. The art historian Susan Larkin has compared the Cos Cob artists to their French counterparts who had summered in Argenteuil a few decades earlier.[1] Impressionists in both these semirural places were seeking more contemplative subjects in nature and the camaraderie of likeminded artists. Carlsen joined Childe Hassam, Willard Metcalf, John Twachtman, J. Alden Weir, and others who supported a culture of artistic innovation inspired by the Connecticut countryside.

Carlsen was born in Copenhagen, where he studied architecture, painting, and sculpture at the Royal Academy. He immigrated to America in 1872 and settled in Chicago, working as an assistant first to an architect and then to the Danish painter Lauritz B. Holst. He took a teaching position at the then recently founded Chicago Academy of Design (now the School of the Art Institute of Chicago). In 1875 Carlsen spent several productive months in Paris, where he briefly attended classes at the Académie Julian. He returned to the United States later that year and took a studio in New York. Back in Paris from 1884 to 1886, he concentrated on still-life painting before moving to San Francisco, where for two years he directed the school of the San Francisco Art Association and, subsequently, had a studio and taught. In 1891 the peripatetic artist accepted an invitation to teach at the National Academy of Design in New York; he remained an instructor there until 1918.

2 *Barnacled Rocks*
ca. 1900–30
Oil on canvas, 15 x 18 in.
Gift of Charles H. Drummond, 1985.0008.001

Carlsen married in 1896 and purchased property in Falls River, Connecticut, in 1905. His distinctive talents and growing friendships with artists such as Twachtman and Weir helped him establish a secure place among the Connecticut impressionists.

Barnacled Rocks vividly demonstrates the nature of Carlsen's impressionism. To capture the churning waves dashing against rocks, he relied on aggressive brushwork, while creating the tranquil blue of the distant sea and sky with a more controlled application of paint. In addition, the composition reflects Carlsen's appreciation for Japanese aesthetics, a penchant he shared with many American and French impressionists. Claude Monet and John Twachtman, for example, treasured their Japanese woodblock prints. Later, modernists would admire the flat zones of unmodeled color, asymmetrical designs, and compositional foreshortening characteristic of this genre. In the Ulrich Museum's canvas, a few simple zones of near monochrome comprise the image. The viewer's heightened vantage point, elevated from the rocky shoreline in the foreground, disrupts recession and contributes to a two-dimensional effect. The asymmetry of the view Carlsen selected energizes the composition and illustrates the artist's embrace of japonisme. The combined impact of these formal characteristics demonstrates the strong modernism of this painting.

Patricia McDonnell

1. Susan G. Larkin, *The Cos Cob Art Colony: The Impressionists on the Connecticut Shore* (New Haven and London: Yale University Press, 2001), 1.

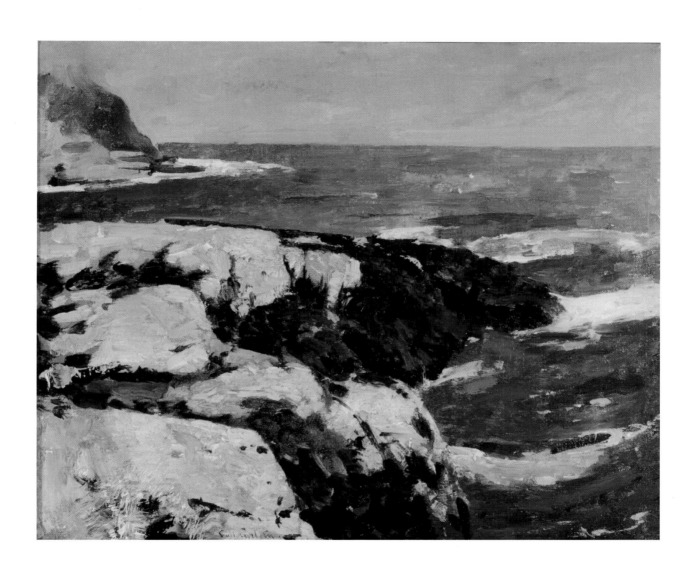

3 *Marchand de vin, 15 rue Boyer*
(Wine Seller, 15 rue Boyer)
1910–11
Albumen print on paper, 8 5/8 x 7 1/8 in.
Museum Purchase, 2004.0018

Atget observes like a novelist, and the extended form of his 10,000 photographs, like long nineteenth-century novels, mirrors the world's abundance and variety. . . . Atget builds his epic like a novelist, but photographs each scene like a poet.

Ben Lifson[1]

THE ACCLAIMED PHOTOGRAPHER EUGÈNE ATGET BEGAN HIS WORKING LIFE AS A SEAMAN, LATER BECOMING AN ACTOR IN THE FRENCH PROVINCES. Not until the 1890s, when looking for an occupation that might provide a reliable livelihood, did he turn to commercial photography – just as the technology had developed to a point where that was becoming a credible business venture. His adoption of the medium coincided with an interest in documenting disappearing Parisian architecture and capturing the fading traditional culture of the French capital. Around 1898, he launched a singular enterprise, supplying documentary photographs to historically minded organizations, such as the archive of the national registry and local museums. He also served a clientele of history painters, architects, set designers, magazine illustrators, and publishers who purchased his images of Paris as source material.

Atget made more than ten thousand photographs of the myriad faces of the city as it transitioned from one century to the next. In his time, he was virtually unknown in the French art world. Today, his reputation rests on the comprehensiveness of his project to record and reflect Paris as it once was as well as on the ardor and dedication that labor entailed. Given the refinement of his images and the wisdom inherent in his aesthetic choices, Atget's work far surpasses simple documentation. In a period when pictorialism – characterized by softly focused, often manipulated images – dominated photography, he took a more straightforward approach. Instead of depicting the progress and bustle of the metropolis, he favored less obvious, more idiosyncratic subjects – a ragpicker's shack, for example, or the calm of a Versailles fountain, or the curious grimace of a sculpted satyr on a church facade. "Atget's best work," noted the scholar Maria Morris Hambourg, "is a poetic transformation of the ordinary by a subtle and knowing eye well served by photography's reportorial fidelity."[2]

Marchand de vin, 15 rue Boyer vividly demonstrates Atget's ability to elevate a seemingly mundane setting to the level of art. Because the interior of the wine bar is dimly lit, sharp contrasts of dark and light animate the composition. To build drama in the image and focus more light on the murky room, Atget positioned his lens to capture reflections cast from the front windows onto the bar mirror. The formal interplay of lines from the open front doors and stair railing, seen in the mirror, resonate with other patterns in the image. Another hallmark of Atget's exceptional style is evident here: the long exposure required to achieve a precise quality of light. What might have been a drab image of a commonplace locale becomes, in his hands, an eloquent work, one among many in his landmark portrait of a now-vanished Paris.

Patricia McDonnell

1. Ben Lifson, *Eugène Atget* (Millerton, N.Y.: Aperture, 1980), 7–8.

2. Maria Morris Hambourg, "Atget, Eugène," in *Grove Art Online*, Oxford Art Online, www.oxfordartonline.com/subscriber/article/grove/art/T004771. Accessed December 15, 2009.

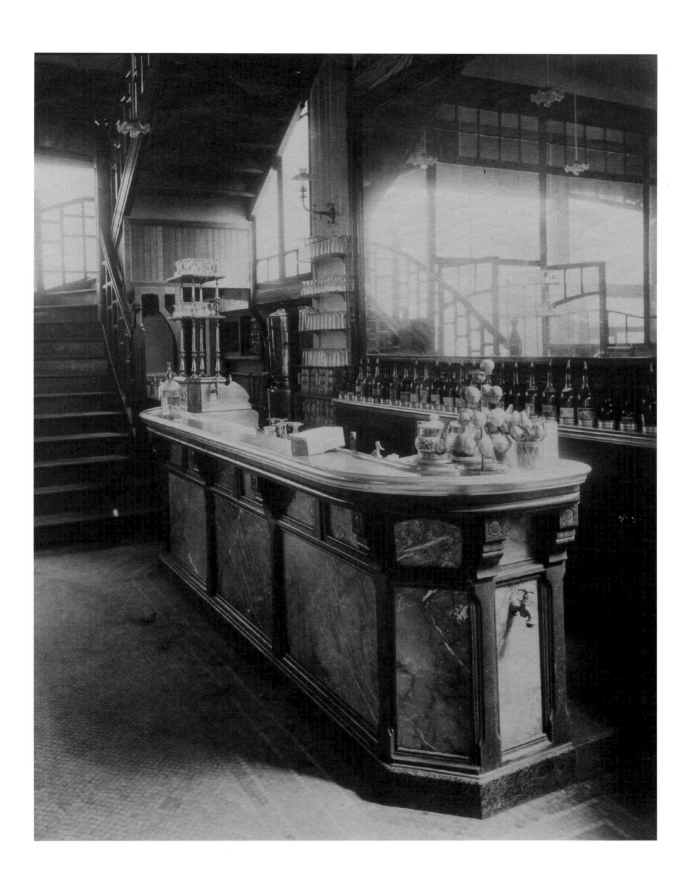

4 *Distant Valley, Montauk*

1924
Oil on board, 13 x 48 in.
Gift of Harry Spiro, 1975.0050

CHILDE HASSAM WAS ONE OF MANY AMERICAN ARTISTS WHO AROUND THE TURN OF THE TWENTIETH CENTURY DEPARTED FROM A FORMAL, ACADEMIC STYLE to adopt the vigorous brushstroke and vivid palette of the French impressionists. Like their European counterparts, these painters produced landscape, figure, and genre works that captured aestheticized glimpses of their subjects in fleeting conditions of light and atmosphere.

In 1898 Hassam helped found the influential group of American impressionists known as The Ten; among its members were Frank W. Benson, John Twachtman, and J. Alden Weir. Hassam played a key role in promoting impressionism within the American art world. These efforts – and the particular popularity of his many urban and coastal paintings among critics, the public, and his fellow artists – led him to be regarded as the preeminent American impressionist.

At his death in 1935, Hassam bequeathed the contents of his studio, including 326 oil paintings, eighty-nine watercolors, and thirty-three pastels, to the American Academy of Arts in New York, stipulating that they be sold to establish a fund for the purchase of works by American and Canadian artists. Once purchased, the art was to be donated to American museums. Sales of the artist's paintings to create the Hassam Fund reaped the present-day equivalent of nearly $3 million. *Distant Valley, Montauk* was one of the works in Hassam's studio, and so its eventual donation to the Ulrich Museum helped fulfill the desire that had motivated him to make his bequest.

The Ulrich's painting is an idyllic view of several people basking in the late-afternoon sun as it casts a glow across a stretch of seaside dunes and shoreline. The image aptly reflects Hassam's life in the 1920s. In 1919 he bought a beautiful eighteenth-century house, called Willow Bend, in East Hampton on Long Island and summered there every year until his death. Many of his later paintings were of subjects in that town and its vicinity. During the 1920s, he made numerous excursions and camping trips to Long Island locales such as Montauk with friends and fellow painters. For Hassam, this painting, which appears to be of a paradise imagined, might actually have been an attempt to depict a paradise he had found.

Timothy R. Rodgers

ONE SETTING, TWO MOODS:

Winter was on its way. Only a few withered leaves clung to indifferent trees, and the stones beneath her feet felt slick with the cold rain that had fallen all morning. The sun was just now trying to come out, but from where she stood, it made little difference. The houses were gray, squat – the unrelenting wall of them blocking her view of the horizon. Only one door was left open. Peering in, she saw the bright square of a window on the other side.

"Sara." Her mother said her name with no emotion, only fatigue in her voice. "You're just standing there. And why would you wear your good coat for this? Come on now. We need your help."

It was true. They did need her help, especially today, when you could feel the frost in the air, patient, waiting to attack when they were in their beds. But every day, there was work to do: something to be picked, pulled, or dug out of the patch of land behind the houses. They would have to get themselves through the cold season, with enough left over for the rent. Inside, it was washing, scrubbing, boiling, and canning. Always something. There was never time for her to read, to play, to sit on the front doorstep and think – not when even her grandmother, with her hurting hands, was bent over, working, her back rounded to the sky.

A crow looked down from a naked branch, eyeing her.

Her mother wore an orange rag on her head, a man's shirt, and a skirt that had lost all trace of its original color.

5 Peasant Landscape
1883
Oil on canvas, 35 3/4 x 24 in.
Gift of Edwin A. Ulrich, 1974.0067.092

Sara nodded to her, hurrying down the path. "Sorry," she said. "I'm coming."

OR:

There were still a few golden leaves on the trees, catching the light of the waning sun. The air felt clean the way cold air does. Sara was warm enough, the row of their neighbors' houses acting as a shield from the wind. The sun had dried the rain from the night before off the stones beneath her feet, and she moved quickly down the path. All of this wetting and drying had been good for the garden: even in the bracing wind, it looked green and lush.

"Sara," her mother said. "You don't need to come help us today. You've had a long day at school. And you're still wearing your good coat."

It was true. It was her good coat, which her mother had made for her to wear to school. And though it was pretty, the color of a bright sky, it was tight across the chest. Wearing it, she couldn't stretch her arms above her head.

She continued down the path until she was beside her mother. She looked up at her, waiting, her basket ready. The scarf around her mother's head was the color of the sun, and her hands were brown with soil. Farther down the path, enormous heads of cabbage seemed to rise up into her grandmother's quick hands. The old woman's apron was bluer than Sara's coat, and it had deep pockets into which she tucked whatever was ripe, the rewards of her knowing and her labor.

Laura Moriarty

The Ulrich's collection includes more than three hundred works by Waugh.

6 *Welcome*
ca. 1910s
Oil and graphite on canvas, 38 x 57 ³/₄ in.
Gift of Michael Scharff, 1974.0092.001

The paintings [of Arthur B. Davies] lead one away entirely into the land of legend, into the iridescent splendor of reflection. . . . Often you have the sensation of looking through a Renaissance window upon a Greek world – a world of Platonic verities in calm relation with each other.

Marsden Hartley [1]

Welcome reflects the distinguishing Arcadian vision and symbolist impulses of Arthur B. Davies. His scene of youth cavorting in an idealized sylvan setting is part balletic choreography, part dreamy idyll. It attempts to emphasize humankind's accord with nature, an ideal that lay at the heart of the symbolist movement from the 1880s until the early twentieth century. The unsettling pace of industrialization and its disruption of cultural norms fostered in many a nostalgic yearning for a more peaceful, bucolic world. Inspired by such artistic precursors as Pierre Puvis de Chavannes and Ferdinand Hodler and in step with contemporaries such as Maurice Prendergast and Odilon Redon, Davies conjured an image of carefree abandon disconnected from early-twentieth-century realities. The influences of Paul Cézanne's Bathers series, painted from the mid-1870s onward, and of the Fauves – the group of artists led by Henri Matisse in the early 1900s – are also evident in the Ulrich's canvas. An admirer of the modern-dance pioneer Isadora Duncan, Davies evokes her naturalistic gestures in the swaying motion of the figures in *Welcome*.

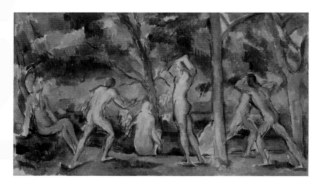

Paul Cézanne (French, 1839–1906), *Bathers*, 1898–1900. Oil on canvas, 10 ⅝ x 18 ⅛ in. The Baltimore Museum of Art: The Cone Collection, formed by Dr. Claribel Cone and Miss Etta Cone of Baltimore, Maryland, BMA 1950.195. Photograph by Mitro Hood.

Davies belonged to a circle of painters known as The Eight (including William J. Glackens, Robert Henri, Ernest Lawson, George Luks, Maurice Prendergast, Everett Shinn, and John Sloan), who collectively pursued artistic models outside the academic norm. The group formed when the conservative National Academy of Design refused to display works by Glackens, Henri, Luks, and Sloan; in 1908 Davies organized an independent show of canvases by The Eight at New York's Macbeth Gallery. Five years later, he led the organization of the 1913 Armory Show, a massive exhibition of modern art. This landmark presentation signaled a turning point for the American art world, which now confidently began embracing and promoting modernism.

Davies was a trusted advisor to the art collectors and Museum of Modern Art co-founders Lillie Bliss, Abby Aldrich Rockefeller, and Mary Quinn Sullivan. A. Conger Goodyear, the museum's first president, acknowledged Davies's instrumental role in its conception.[2] Although his own work was not at the radical forefront of his time, Davies championed experimentation and innovation. His lyrical paintings, political skills, and open mind won him hearty praise from critics, collectors, and fellow artists alike.

Patricia McDonnell

1. Marsden Hartley, "Arthur B. Davies," in Hartley, *Adventures in the Arts* (New York: Boni and Liveright, 1921), 80–81.

2. A. Conger Goodyear, *The Museum of Modern Art: The First Ten Years* (New York: Museum of Modern Art, 1943), 13–14.

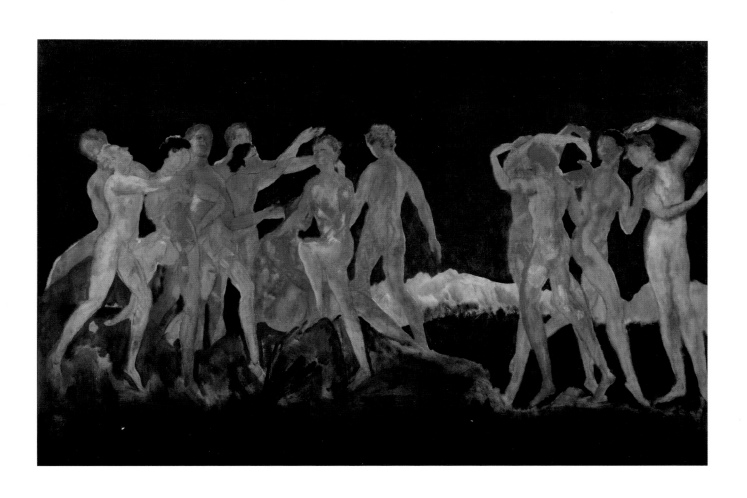

CHARLES GRAFLY WAS AMONG AMERICA'S MOST SOUGHT-AFTER PUBLIC SCULPTORS OF THE EARLY TWENTIETH CENTURY, a time that saw a surge in the popularity of Civil War memorial monuments and sculptural adornments to building exteriors. A native of Pennsylvania, he was trained in the classical tradition at the Pennsylvania Academy of the Fine Arts in Philadelphia (where he studied under Thomas Eakins) and later was schooled at the Académie Julian and Ecole des Beaux-Arts in Paris. From 1892 until his death, he taught at the Pennsylvania Academy. Grafly's most notable projects included the sculptural program for the U.S. Customs House in New York (1907) and the memorial to the Union Army general George Meade in Washington, D.C. (1927).

In 1971 Grafly's daughter, Dorothy, and her husband, Charles H. Drummond, donated the contents of the artist's studio, which included paintings, plaster casts, cast bronzes, drawings, and tools, to Wichita State University along with funds to establish an endowment for collection care. Today, the artist's personal papers, which the Drummonds also donated at that time, are maintained in Special Collections and University Archives in the Ablah Library. The Ulrich Museum, meanwhile, is responsible for more than six hundred works, including the original plaster casts for many of his sculptures. In 2005 the Ulrich opened the Grafly Garden – featuring six of his sculptures and a stately colonnade, interspersed with foliage – adjacent to the museum and the McKnight Art Center.

The artist made *Pioneer Mother* as part of his commission to produce a large-scale bronze sculpture for the Palace of Fine Arts at the 1915 Panama-Pacific International Exposition in San Francisco. The exposition not only celebrated the completion of the Panama Canal but also showcased San Francisco's rapid recovery from the catastrophic 1906 earthquake and fire. The fairgrounds arose on 635 acres of landfill located in what is now the city's Marina district. The only building not razed after the fair was the Palace of Fine Arts; it was completely rebuilt in the 1960s. In 1999 the organization San Francisco Beautiful recognized Grafly's sculpture, which had been moved to Golden Gate Park, with its Beautification Award for contributing to the city's aesthetic appeal.

7 *Pioneer Mother*
1914–15
Bronze, 15 x 8 1/4 x 4 in.
Gift of Mr. and Mrs. Charles H. Drummond
1982.0027.047

Grafly's bronze was intended as "an enduring memorial to those brave, loyal, and self-sacrificing women who made the American civilization of the State of California possible."[1] The Pioneer Mother Monument Association awarded him the project after considering nine of the nation's leading sculptors, Daniel Chester French and Frederick MacMonnies among them. Grafly submitted several designs to the association, which chose one that differs from the Ulrich piece. Even though the proposed version represented here was not selected, Grafly himself liked it enough to cast it in bronze. The woman's erect, confident stance recalls the noble graces of Greek antiquity as much as it does courageous frontierswomen. Sculptures embodying the classical Greek muses typically hold a writing tablet, a globe, or a lyre, but this stalwart figure symmetrically balances two infants aloft. True to a popular early-twentieth-century mode, Grafly employed the artistic language of the Beaux-Arts school to render this mother of the pioneer West.

Patricia McDonnell

1. "All Honor to the Pioneer Mothers of California," *Overland Monthly* 64, no. 1 (July 1914): 439.
The Ulrich's collection includes more than six hundred works by Grafly.

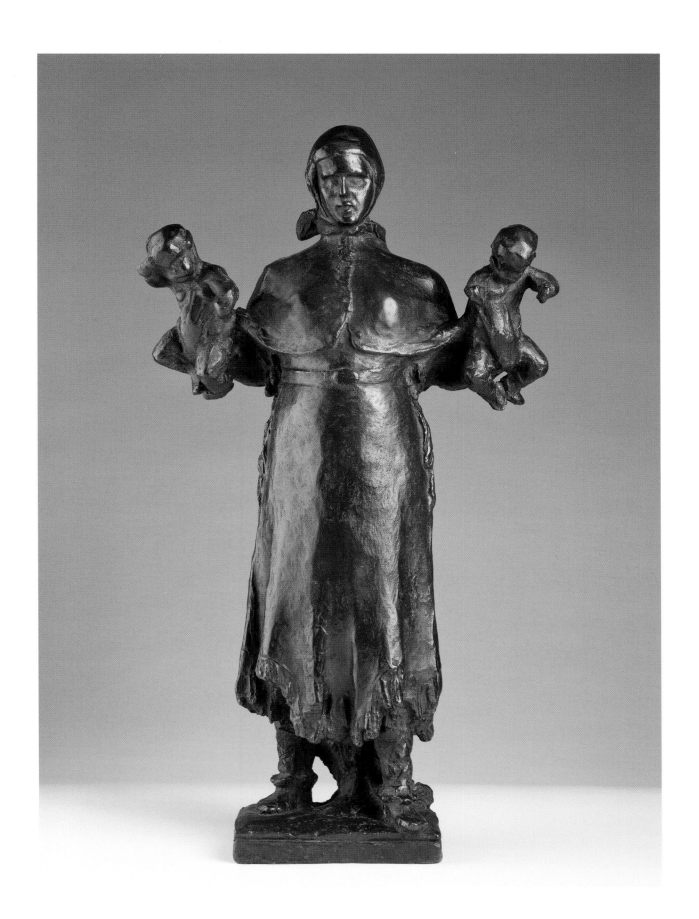

8 *Gregorita with the Santa Clara Bowl*
1917
Oil on canvas, 32 x 26 in.
Gift of Arthur W. Kincade in memory of
his wife, Josephine Kincade, 1977.0002

ROBERT HENRI PLAYED A SIGNIFICANT ROLE IN THE AMERICAN ART WORLD OF THE EARLY TWENTIETH CENTURY, when he and seven other trailblazing painters – Arthur B. Davies, William J. Glackens, Ernest Lawson, George Luks, Maurice Prendergast, Everett Shinn, and John Sloan – displayed their depictions of everyday city life, including the lives of poor people, in New York galleries. Not all viewers appreciated the efforts of this group, which was called The Eight. After one critic suggested throwing their works into an ash can, several of these artists, along with others such as George Bellows and Edward Hopper who likewise painted frank urban scenes, collectively became known as the Ashcan school.

Henri's quick, fluid painting style and proletarian subject matter – inspired by Frans Hals, Édouard Manet, and Diego Velásquez – no longer seemed radical in the wake of the Armory Show, the mammoth 1913 exhibition of works by Marcel Duchamp, Wassily Kandinsky, Pablo Picasso, and others that opened many American eyes to modernism for the first time. In 1914, searching for new inspiration and, perhaps, for a new aesthetic direction, Henri traveled to the American West. His respect for Native Americans and Hispanics prompted him to visit the 1915 Panama-California Exposition in San Diego, where the cultures of those peoples were highlighted. There he met Dr. Edgar L. Hewitt, a New Mexico ethnologist, who secured a workspace for him in Santa Fe's Palace of the Governors Museum. Over the course of three stays in New Mexico, Henri produced more than two hundred paintings, mostly portraits of Native Americans and Hispanics.

Henri painted the model who posed for *Gregorita with the Santa Clara Bowl* several times. The young woman sits next to a large storage jar, which she grasps with her right hand. The frontal presentation and direct gaze are typical of Henri's portraits. He hoped viewers would respond to his subjects with respect and empathy and thus recognize their shared humanity. At the same time, he wanted viewers to distance themselves from his subjects, acknowledging them as representatives of their races; this perspective is rooted in nineteenth-century social science, which advocated the acceptance of distinct races with shared identifying characteristics. Before and after spending time in New Mexico, Henri went to Spain and Ireland, producing many more portraits that displayed both the individuals' personalities and what he (and many others) considered traits that typified their ethnicities.

Henri's musings about art, assembled in the book *The Art Spirit* (1923), brought him a stronger reputation both as a theorist and as a painter. Artists today still find inspiration in his admonition to seek beauty in everyday life.

Timothy R. Rodgers

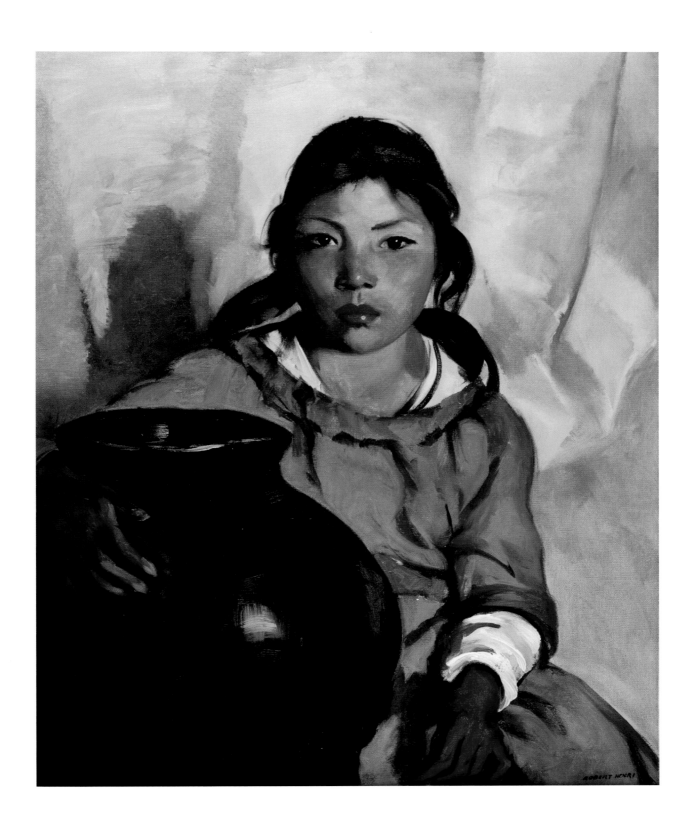

9 *Daisies and Peonies*
ca. 1930s
Watercolor on paper, 13 x 18 ½ in.
Gift of Dr. Theodore Leshner, 1974.0089

A FEW EVENINGS AGO, I TOOK MY FIVE-YEAR-OLD DAUGHTER TO THE LIBRARY, and on our way out, we saw a sign on the door of the auditorium: "BELLY DANCERS TONIGHT, 7:00!" I looked at my watch. Two 'til seven. I looked at my daughter. "You want to see some belly dancers?"

She squinted up at me, needing more information.

I raised my arms, moving my hips a little. She frowned.

"No, you'll like it," I said. "Belly dancers. Like Princess Jasmine in *Aladdin*."

"She's not a dancer," my daughter said, but she walked past me into the auditorium.

Of course. I had made the magic reference. My daughter, true to her marketing demographic, loves the Disney princesses, those animated beauties with heroic hearts. I appreciate that the princesses are more ethnically diverse than they were when I was a girl. I had Snow White, Sleeping Beauty, and Cinderella. My daughter loves those Anglo beauties, but she also loves Pocahantas, Mulan, Esmeralda, Tiana, and the aforementioned Jasmine. (To be fair, I should mention that Esmeralda and Mulan aren't princesses. They're just brave and beautiful, so they get to run with the pack.) Still, even the new princesses all share one body type: not too tall, slender, with perky but unobtrusive breasts, the faintest trace of hips, an invisible butt, and a tiny waist.

Early on, I tried to steer my daughter's interest toward Dora and Lilo – both squat, sturdy little creatures who actually look vital enough to undertake all of their cartoon adventures. My daughter likes them well enough. But she longs for the princesses, just as she longs for their more-endowed sister, Barbie. I know some parents of young girls censor these images and toys, rightly worried about planting early desires for a rare, if not impossible, body type and dissatisfaction with anything else. I considered banning them myself. But it seemed like trying to hold back the tide. The wasp-waisted ladies are everywhere, in every toy store and bookstore, and on the backpacks and T-shirts of friends. My daughter's school keeps a box of Barbies as one of several rewards for good behavior. The marketing and the strong preference start to seem like a chicken-and-egg scenario. Maybe you can't blame the marketing. Maybe the preference comes first.

And yet, the belly dancers: When they first appeared in the auditorium, I held my breath, my right hand poised to clamp over my daughter's mouth. Like most five-year-olds, she has a tendency to speak her mind, and I wasn't sure what she was thinking. Like the princesses, the belly dancers represented a range of skin colors: two were white and two black. Unlike the princesses, they represented a range of body types. One dancer was slender. The others, to varying degrees, were not. Yet they all stood smiling before us, bellies bared, hips accented with jingling belts, jewels pressed into their foreheads and onto the backs of their hands. My daughter stared at the one who smiled the most, the one with sunflowers and beads in her hair. When the music started, the others followed her lead, and it turned out there were strong, practiced muscles under even the looser bellies. Scarves twirled over their heads.

"Oh, Mommy," my daughter whispered, mesmerized, and with all the certainty of her youth. "They're all so beautiful."

Laura Moriarty

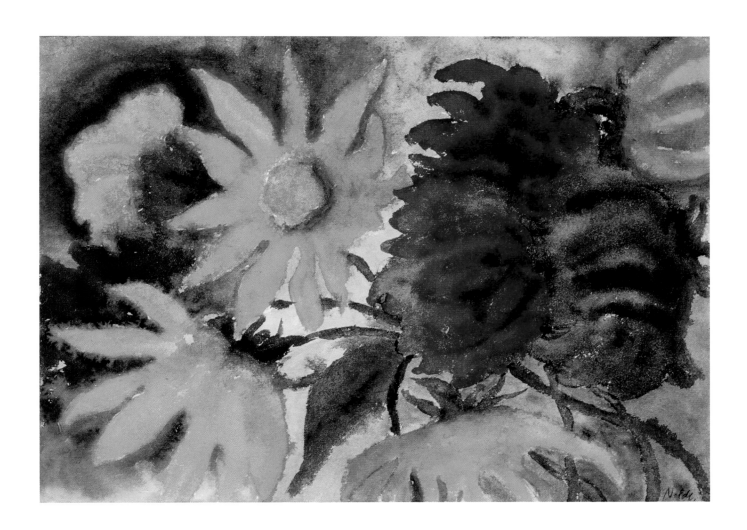

WHEN IMOGEN CUNNINGHAM BEGAN MAKING PHOTOGRAPHS, IN 1901, THE MEDIUM WAS JUST SIX DECADES OLD. *Clare and Floating Seeds* represents an important early moment in her development, one that was largely unknown until she received a Guggenheim Foundation fellowship in 1973 that enabled her to create new prints from her early glass plates.

Born in Portland, Oregon, Cunningham attended the University of Washington in Seattle, where her chemistry professor encouraged her interest in studying photographic processes. Meanwhile, she also worked for the university's botany department, capturing images of plants. After graduation in 1907, Cunningham found employment in the Seattle portrait studio of Edward S. Curtis, now renowned for his photographs of Native Americans. Thanks to a scholarship, she was then able to spend a year at the Technische Hochschule in Dresden, concentrating on photographic-development techniques.

In 1910, the year the Ulrich's photograph was taken, Cunningham returned to Seattle and opened a portrait studio. Until 1917, when she moved with her artist husband, Roi Partridge, to the San Francisco Bay Area, she created lyrical images in the pictorialist vein. In their effort to establish photography as an art form, early practitioners of this genre evoked the imagery of naturalist and impressionist painters through the use of soft focus, arresting nature scenes, and romanticized subject matter. Pictorialists favored emotional expressiveness over empirical exactness, often depicting scenes from Romantic poetry, medieval legend, or the Bible. Employing simple costuming, artful staging, and dramatic lighting, many imbued their images with allegory.

Because of Cunningham's admiration for the nineteenth-century British artists William Morris and Dante Gabriel Rossetti, one critic characterized her work from the first decade of the twentieth century as "Pre-Raphaelite."[1] Cunningham herself said she was most inspired during those years by Gertrude Käsebier, whose photographs she saw in the *Craftsman* magazine.[2]

10 *Clare and Floating Seeds*

1910
Gelatin silver print on paper
20 x 15 in. (sheet); 10 5/8 x 8 in. (image)
Museum Purchase, 1979.0001.001

Cunningham's artist friends Clare Shepard and John Butler served as compliant models for a series of photographs. They posed in misty woods or at twilight so Cunningham could seek a dramatic, timeless effect. Here, Clare gazes thoughtfully at milkweed seeds drifting up her arm and over her shoulder. Allegorically, the image suggests a woman contemplating her fecundity and capacity for motherhood. In doing so, it recalls work by women photographers such as Käsebier and Julia Margaret Cameron and painters such as Cecilia Beaux and Mary Cassatt.

Cunningham's reputation, however, is not due to her dreamy early pictorialism but to her later pursuit of a distinctly different vision. After moving to San Francisco, she joined a circle of photographers who rejected soft focus in favor of imagery that was crisp, clean, and exacting – a reflection, they felt, of modernity itself. In 1930 Cunningham, Ansel Adams, Edward Weston, and several other friends founded the f/64 group in order to promote photographic precision. Cunningham became known for her striking close-ups of plant forms, stark pictures of industrial buildings, and portraits for *Vanity Fair* magazine.

Patricia McDonnell

1. Margery Mann, *Imogen!*, exh. cat. (Seattle: Henry Art Gallery in association with the University of Washington Press, 1973), 11.

2. James Danziger and Barnaby Conrad III, "Imogen Cunningham," in Danziger and Conrad, *Interviews with Master Photographers* (New York: Paddington Press, 1977), 39.

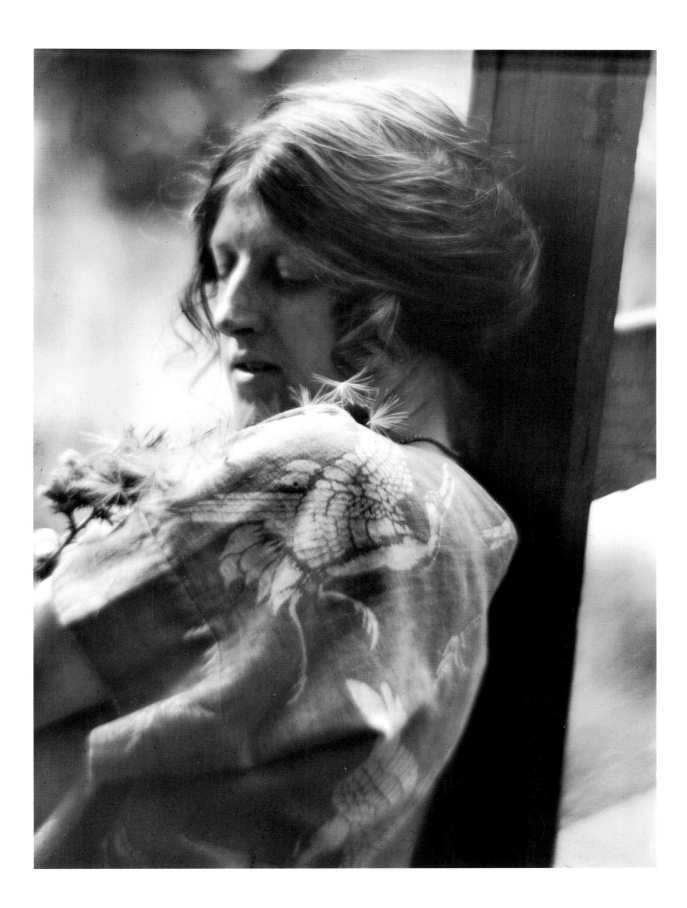

11 *Boats in Yellow Sea*
1944
Gouache on paper, 22 ½ x 31 in.
Gift of Sally Avery and Mr. and Mrs. Floyd T. Amsden
1974.0046

*Avery's landscapes and seascapes undoubtedly constitute his sublime achievement,
and there is nothing in current painting to which one might profitably compare them.*

Hilton Kramer[1]

THE CRITIC HILTON KRAMER'S PRAISE FOR MILTON AVERY'S SUCCESSFUL PURSUIT OF HIS TWO CHIEF MOTIFS, LANDSCAPES AND SEASCAPES, reflects the artist's importance among American painters and critics near the end of his life. Yet earlier in Avery's career, the forms of his work were dismissed, first, as radically abstract and later, when abstract expressionism held sway, as too representational. Both reactions were misplaced, however, because form – whether representational or abstract – was of secondary concern to Avery. It was color that primarily inspired him, defined his images, and ultimately secured his reputation.

In the spirit of the French artist Henri Matisse, Avery used color relationships to convey emotion, spatial depth, light, and movement. The water surrounding the trio of small vessels in *Boats in Yellow Sea* is an unlikely yellow-tan that gently contrasts with the grayish purples of the boats. Diluted pink and brown-red accents complete the palette. The muted colors convey a sense of quiet and calm. One can easily imagine little waves gently jostling the moored crafts on a cloudy but peaceful day.

Inspired not only by Matisse but also, perhaps, by Japanese prints, children's drawings, and folk art, Avery preferred to create nearly abstract imagery with flat areas of color rather than the precise shapes of the objects or the illusion of three-dimensional space. For example, the two small boats look out of scale in relation to the larger vessel in the foreground, and all three are simple cutout forms, barely shaded. In addition, the wooden dock in the background unrealistically appears to hover above the scene.

Like Matisse, Avery felt free to push aside rules of perspective and drawing that had guided artists since the Renaissance. Yet the fact that his paintings are never wholly divorced from representational subject matter separated him from his abstract expressionist peers. Yet several of them, especially his friends Adolph Gottlieb and Mark Rothko, appreciated Avery's lyrical sense of color and inventive patterning of flat forms.

Timothy R. Rodgers

1. Hilton Kramer, *Milton Avery: Paintings, 1930–1960* (New York: A. S. Barnes, 1962), 19.

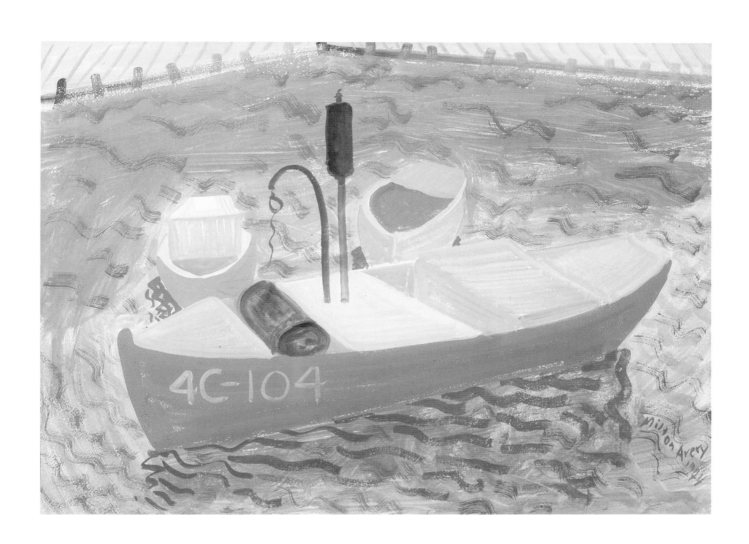

AFTER SEVERAL DAYS OF TRYING TO PHOTOGRAPH A "GLORIOUS" NEW PEPPER, EDWARD WESTON EX-CLAIMED, "I'M NOT SATISFIED YET!" Then he placed it in a tin funnel – "a bright idea, a perfect relief for the pepper and adding reflected light to important contours." After printing the image, he proclaimed it "a peak of achievement":

> It is classic, completely satisfying, – a pepper . . . but more than a pepper: abstract, in that it is completely outside subject matter. It has no psychological attributes, no human emotions are aroused: this new pepper takes one beyond the world we know in the conscious mind. . . . into an inner reality, – the absolute, – with a clear understanding, a mystic revealment. . . . seeing "through one's eyes, not with them": the visionary.[1]

Although the photograph's value as proof of these exalted philosophical claims might be uncertain, there is no question about its value as a demonstration of Weston's photographic ability. *Pepper* is a classic photograph, one of the most famous images by one of the most famous of all photographers.

Weston began as a pictorialist, making dreamy, soft-focus images printed on matte paper. He then adopted a more modern style, turning to sharp focus and glossy prints that would produce what he believed the camera did best: a "stark beauty" based on the exact rendering of rhythm, form, and detail.[2] Often that meant creating a close-up view, for clarity and concentration. Weston insisted that he wanted to reveal "the very substance and quintessence of the *thing itself*."[3] If the idea of rendering tone and contour seems like a throwback to the language of drawing, it was nonetheless fundamental to his approach. In this case, the sheen of the pepper's surface and the brilliant highlights are set off by the equally intense dark areas, making the form compelling and mysterious. The funnel – and Weston's skill – made that possible. But he always argued that "art is a way of seeing, not a matter of technique."[4]

12 *Pepper*
1930 (posthumously printed by Cole Weston)
Gelatin silver print on paper, 9 1/4 x 7 1/4 in.
Museum Purchase, 1989.0001.002

This is a pepper with character, and despite Weston's assertion that the image is abstract, presenting a subject with no inherent significance, it has elicited all kinds of responses. For example, the critic Susan Sontag, alluding to this and other Weston photographs, thought his "notions of beauty" had, with time, become "banal," an outmoded high-modernist cliché.[5]

For all his talk of "mystic revealment" and his adherence to a purist approach to art, Weston also had a playful side, as is evident in what he wrote about the pepper's fate: "It has been suggested that I am a cannibal to eat my models after a masterpiece. But I rather like the idea that they become a part of me, enrich my blood as well as my vision."[6]

Robert Silberman

1. Edward Weston, *The Daybooks of Edward Weston*, ed. Nancy Newhall, 2 vols. (Millerton, N.Y.: Aperture, 1973), II: 179–81.

2. *Daybooks*, II: 147.

3. *Daybooks*, I: 55. Weston's emphasis.

4. *Daybooks*, II: 156.

5. Susan Sontag, *On Photography* (New York: Farrar, Straus and Giroux, 1977), 100.

6. *Daybooks*, II: 180.

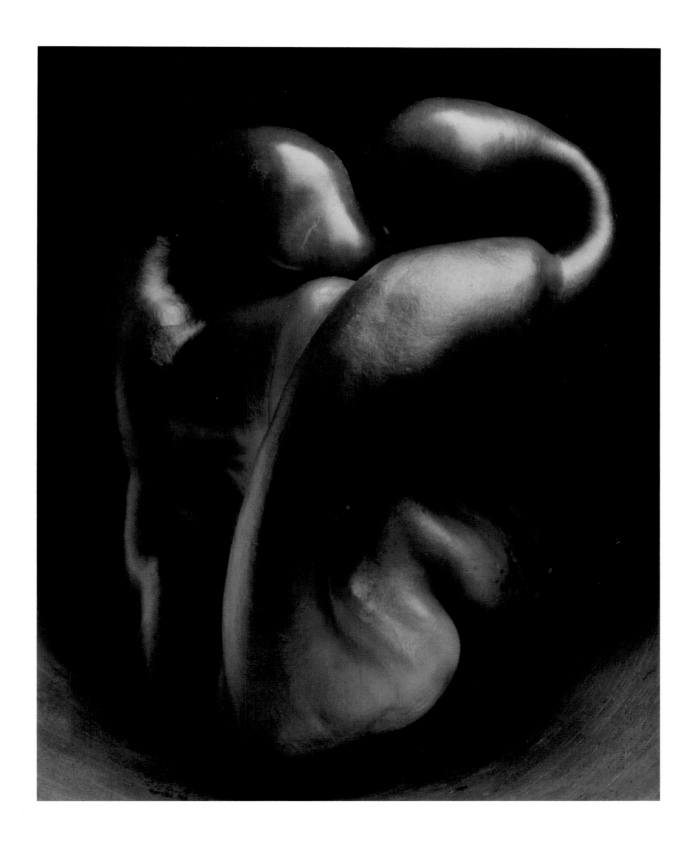

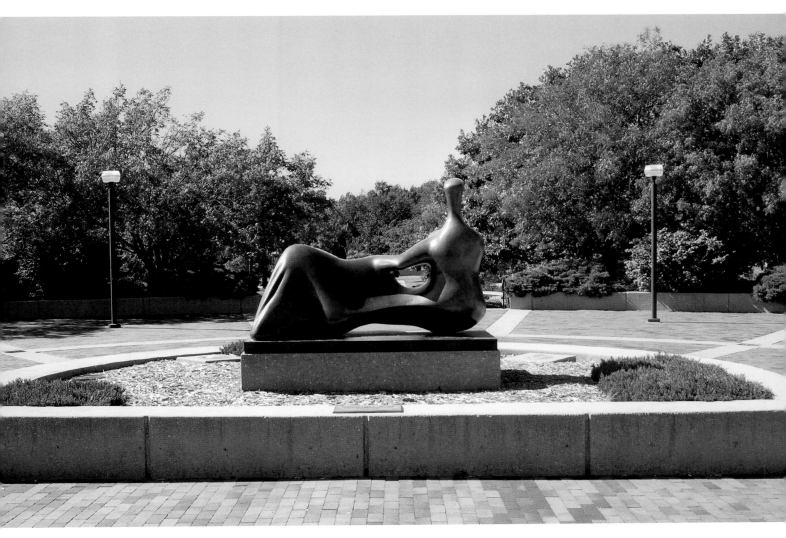

Henry Moore (English, 1898–1986), *Reclining Figure (Hand)*, 1979. Bronze, 65 x 88 x 52 in. Gift of Louise and S. O. Beren, Mildred and Allen Staub, and MISCO Charitable Trust through the generosity of Henry Moore, 1982.0004.

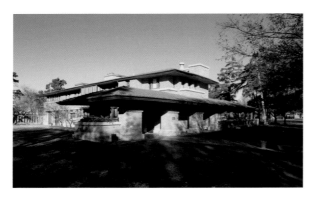

Frank Lloyd Wright, Henry J. Allen House, 1915. Courtesy Allen-Lambe House Foundation, Wichita. Photograph by Larry Schwarm.

FROM THE EARLY 1890S UNTIL ABOUT 1918, FRANK LLOYD WRIGHT CREATED A SERIES OF HOUSES THAT WERE DRAMATICALLY SIMPLE AND SPARE COMPARED TO THEIR STILL-POPULAR VICTORIAN-ERA COUNTERPARTS. Likening their low horizontal lines to the dominant landscape of his native Midwest, he called them his "prairie style" homes. Inside, he erased traditional room divisions to create free-flowing interior spaces and designed furniture to work harmoniously, both in form and function, within them. "The most satisfactory apartments," Wright claimed, "are those in which most of the furniture has been built in as a part of the original scheme . . . as it is the only means of arriving at the very best results."[1] Ultimately, he sought to make exterior and interior merge so that all parts of the home would interweave in a seamless whole.

Wright and his frequent collaborator George M. Niedecken created the present dining set for the home the architect had produced in 1915 for the Wichita newspaper publisher (and later Kansas governor) Henry J. Allen and his wife, Elsie. A Milwaukee–based designer, Niedecken partnered with Wright on eleven houses over fifteen years. Like Wright, he collected Asian art and sought artistic inspiration in nature; his straightforward furnishings reflected the influence of the Arts and Crafts movement as well as Wright's desire to integrate all aspects of a home.

13 Henry J. Allen House Dining Set
1917
Walnut, walnut veneer, and cloth upholstery
Table: 29 1/2 x 42 x 144 1/2 in. (fully extended)
12 chairs: 40 x 18 x 18 in. each
Gift of Arthur W. Kinkade
1982.0006.00.a–f; 1982.0006.002.1–12

The Allen House furniture comprises pieces originated by Wright, originated by Wright and modified by Niedecken, and originated by Niedecken. He modified Wright's dining-table design by lowering the chair backs, adjusting their rear stretchers, and altering the table's extension system.[2] With five leaves, the table expands to fill the dining room and accommodate up to a dozen people, who would sit below twelve wood-framed art-glass lighting panels. The table and high-backed chairs further delineate the space, creating a hallmark Wright effect – that of an intimate room within a room.

Wichita State University once owned the Allen House; it is now a historic-house museum run by the Allen-Lambe House Foundation. In addition to the dining set, the Ulrich Museum has a dressing table, a cabinet tabouret, and two twin beds on loan to the foundation. The Allen House and the Corbin Education Center on the Wichita State campus are the only two Wright-designed buildings in Kansas.

Emily Stamey

1. Frank Lloyd Wright, "The Architect and the Machine," lecture, University Guild, Evanston, Illinois, 1894, in Bruce Brooks Pfeiffer, ed., *Frank Lloyd Wright: Collected Writings*, 5 vols. (New York: Rizzoli in association with the Frank Lloyd Wright Foundation, 1992), 1: 22.

2. The original dining-set drawings, with Niedecken and Wright's notes, are reproduced in Cheryl Robertson, *The Domestic Scene, 1897–1927: George M. Niedecken, Interior Architect*, 2nd ed. (Milwaukee: Milwaukee Art Museum, 2008), 89–90.

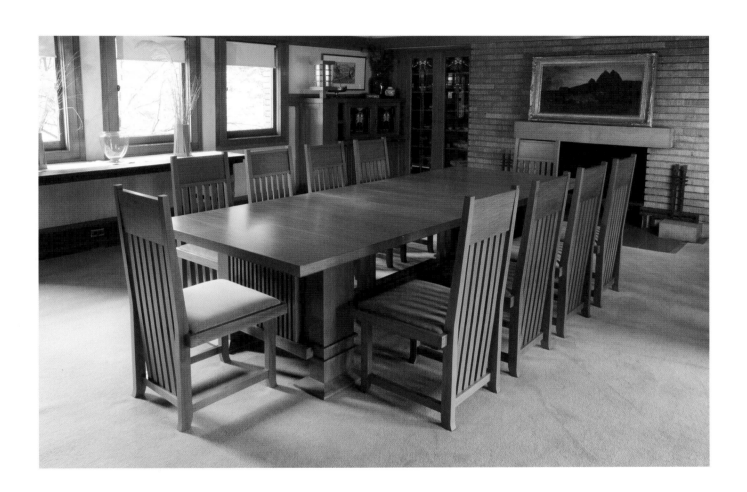

George Grosz's reputation rests on the daring paintings he made in Weimar Berlin, reflecting post–World War I life there and the disillusionment many European intellectuals felt in the wake of the war. Grosz had shifted in the early 1910s from work that reflected his classical training to an embrace of expressionism. His commitment to the avant-garde deepened during the war, accelerated by a mental breakdown he suffered due to combat experiences in the German army. From 1918 through the early 1930s, he created scores of images – as a painter, illustrator, and caricaturist – that indicted inept bureaucrats, villainous capitalists, and immoral politicians. The targets of his vitriolic satire were members of the establishment whose self-interest, he believed, condemned society to moral bankruptcy. Grosz drew fully from the modernist arsenal – bold colors, energetic and jumbled compositions, distorted figures, and cubist geometries – to transmit his vision.

During the summer of 1932, Grosz taught at the Art Students League in New York. He went back to Berlin that fall, only to escape the Nazis narrowly in January 1933 (the month Adolf Hitler was appointed Germany's chancellor) and return to New York, where he settled. He resumed teaching at the League and enjoyed increasing success, with major shows at the Art Institute of Chicago in 1938, the Museum of Modern Art in 1941, and the Whitney Museum of American Art in 1954. Grosz remained in America until 1959, when he returned to Germany, dying there that year.

Early on in New York, Grosz worked primarily in watercolor, alternately celebrating his adopted metropolis and portraying scenes of horror. The latter images recall the apocalyptic landscapes his fellow Berlin expressionist Ludwig Meidner painted in 1912 and 1913, but they also are tied to Grosz's own nightmarish battlefield memories.

Ludwig Meidner (German, 1884–1966), *Apocalyptic Landscape*, 1913. Oil on canvas, 37 ½ x 31 ⅝ in. Collection of the Los Angeles County Museum of Art, Gift of Clifford Odets.

14 *Apocalyptic Landscape*
1936
Watercolor and ink on paper, 17 x 24 ¾ in.
Gift of Dr. and Mrs. Frederick Ziman
1984.0017.023

By 1936, the year Grosz produced *Apocalyptic Landscape*, the Nazis had spent several years consolidating their authority through violence. On February 27, 1933, they burned the Reichstag (Parliament) building in Berlin. In a five-day blood purge that started on June 30, 1934, they murdered nearly eighty of Hitler's political opponents alleged to have plotted against him and eliminated members of the Nazi party's radical wing. With the death of German president Paul von Hindenburg on August 2, Hitler claimed the title *Führer und Reichskanzler* (Leader and Chancellor of the Reich), formally becoming head of both state and government – in effect, Germany's dictator. To Grosz, an artist already highly sensitive to political corruption and violence, these and subsequent events in his homeland portended disaster for Europe.

Grosz abstracts the scene in *Apocalyptic Landscape* by activating the entire sheet. The orb at the upper right and faint horizon line subtly suggest a landscape. Yet the overall patterning heightens the work's abstraction and provokes a sense of omnipresent terror. A master of the watercolor medium, Grosz here created a strikingly modern painting that is at once beautiful and horrific.

Patricia McDonnell

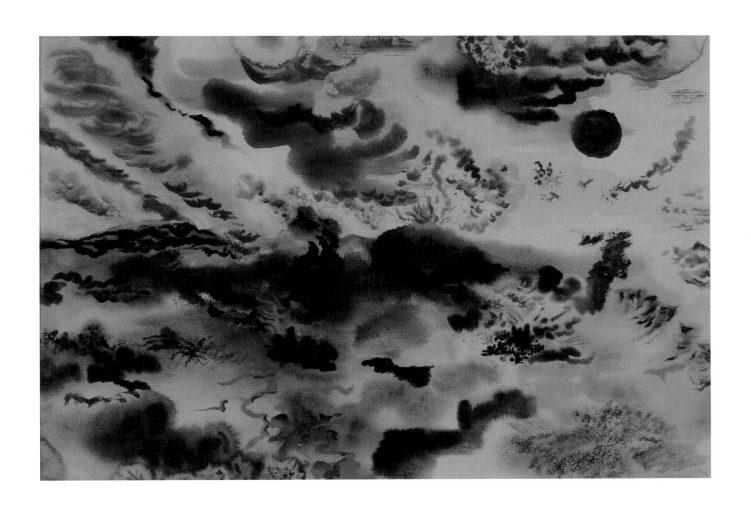

JOAN MIRÓ WAS A PIONEERING TWENTIETH-CENTURY SURREALIST WHOSE EXPERIMENTS WITH CHANCE AND THE UNCONSCIOUS YIELDED NEW EXPRESSIVE POSSIBILITIES AND PICTORIAL VOCABULARIES. Born in Barcelona, he spent most of his adulthood in France, where he was a leading figure in the School of Paris.

Miró drew *Signes et Symbols* in Paris, two years after the outbreak of the Spanish Civil War. He had fled there to escape the hostilities and would stay until 1940. Even before the war, he had been giving artistic vent to his apprehension about the rise of political turbulence across Europe. Later, he would call this his "savage period." Tragic and horrific subject matter, vigorous paint handling, and extreme formal distortion characterized many of his works from 1934 through the late 1930s, a period of unease and creative difficulty for the artist. As the poet and art critic Jacques Dupin put it, "A poetic universe had suddenly been struck with terror."[1] Both Miró and his countryman Pablo Picasso responded to the atrocities being carried out in their native Spain, and each produced a major canvas – *The Reaper* and *Guernica*, respectively – for exhibition at the Spanish pavilion of the Paris Exposition Universelle in July 1937, to protest the intensive air attack on the defenseless Basque town of Guernica that April.

Signes et Symboles is a product of this disturbing moment in world history and in the artist's life. Fecundity, connection with the heavens, the exhilaration of flight, life's natural cycles – none of these previous, optimistic themes in Miró's work occupies him here. Instead, a black ground contrasts with an anxious white line. A smudged umber gouache frames hieroglyphic forms that vaguely suggest figures on a stage set. The drawing appears spontaneous and erratic: little is settled, and much is left in nervous agitation. Miró readily recognized that current events intrude on even the most apolitical artists. "The outer world," he wrote in 1939, "always has an influence on the painter. [T]hat goes without saying. If the interplay of lines and colors does not expose the inner drama of the creator, then it is nothing more than bourgeois entertainment."[2] Holed up in a cramped Paris studio, watching his homeland fall prey to fascist aggression, he poured his anxieties into his art. Miró had been among the first artists to tap the psyche directly as a creative resource. Now, that practice yielded art reflecting immense inner turmoil.

15 *Signes et Symboles* (Signs and Symbols)
1938
Gouache and chalk on paper, 27 1/2 x 40 3/4 in.
Gift of Cornell Jaray, 1976.0018

Patricia McDonnell

1. Jacques Dupin, "Miró's Woman in Revolt, 1938," in *Joan Miró: A Retrospective*, exh. cat. (New York: Solomon R. Guggenheim Museum in association with Yale University Press, 1987), 41.

2. Joan Miró, *Cahiers d'art* 14 (April–May 1939), quoted in Margit Rowell, ed., *Joan Miró: Selected Writings and Interviews* (Boston: G. K. Hall, 1986), 166.

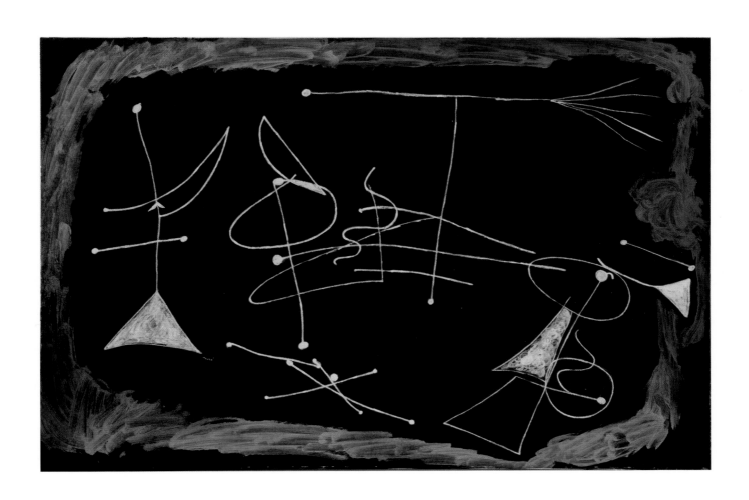

PERSONNAGES OISEAUX, JOAN MIRÓ'S MOSAIC MURAL ON THE SOUTHERN-EXTERIOR WALL OF THE McKNIGHT ART CENTER'S EASTERN SECTION, IS A VITAL SYMBOL FOR THE ULRICH MUSEUM OF ART, WICHITA STATE UNIVERSITY (WSU), AND THE CITY OF WICHITA. A native of Barcelona who was mainly based in Paris, Miró was a key surrealist in the period between the world wars. His work enjoyed international success.

In 1923 Miró embraced the surrealist principle of automatism – that is, allowing the unconscious, rather than logic and reason, to guide the creation of a work. As he wrote a year later, "My latest canvases I conceived as if thunderstruck, totally disengaged from the external world." [1] Like other surrealists, Miró frequently let dreams suggest his subject and how to represent it.

Personnages Oiseaux contains core ingredients of Miró's art. Colorful elements float freely across an expansive field. Perspective and modeling are absent, and the linear patterning suggests a sprightly calligraphy. According to the title, the abstracted figures are fantastical bird people. Miró regularly depicted birds, stars, and people to reflect his profound faith in humanity. The brilliant colors and fanciful creatures in the Ulrich mural embody the joyous celebration of life that is typical of his mature work.

Although best known as a painter, Miró was also an enthusiastic experimenter. "I have always been interested in media other than paint," he wrote in 1960.[2] The Ulrich commission gave him his first opportunity to design a major work that would be executed chiefly in glass. Seventeen years before creating *Personnages Oiseaux*, he painted a large-scale canvas for Harvard University's Harkness Commons that was reproduced as a ceramic mural (1960–61). His other significant ceramic murals include those at UNESCO headquarters in Paris (1956), the Solomon R. Guggenheim Museum in New York (1963–67), the Barcelona airport (1970), and the world's fair in Osaka, Japan (1970). For the Wichita project, he asked that Ateliers Loire in Chartres, France, a specialized decorative-stained-glass manufacturer, fabricate his design. An estimated one million pieces of glass and marble comprise the twenty-eight-by-fifty-two-foot expanse. *Personnages Oiseaux* is the only mural Miró made in this medium, although he later designed stained-glass windows for the Maeght and Cziffra art foundations in France.

16 *Personnages Oiseaux* (Bird People)
1977–78
Venetian glass and marble, 316 x 625 in.
Museum Commission with funds from
Dr. and Mrs. Clark D. Ahlberg, Mr. and Mrs.
Floyd T. Amsden, Mr. and Mrs. A. Dwight
Button, Mr. and Mrs. Robert E. Buck,
Dr. Martin H. Bush, Vincent D'Angelo,
Fourth National Bank and Trust Company,
Mr. and Mrs. Francis Jabara, William T. Kemper,
Mr. and Mrs. Robert M. Kiskadden, Victor
Murdock Foundation, Price R. and Flora Reid
Foundation, Dr. and Mrs. James J. Rhatigan,
Mr. and Mrs. Earl O. Robinson, Edwin A.
Ulrich, Mrs. K. T. Wiedemann, and the Student
Government Association, 1978.0009

The museum's founding director, Martin H. Bush, conceived and directed the commission. Miró generously donated his design. WSU students and private donors funded production. The mural is among the largest of numerous public-art commissions Miró undertook late in his career. "Doing work for public places is one of my passions," he said in 1960. "The first mural I did was commissioned by an American university [Harvard]. I was fascinated by the idea because it would put me in touch with those students who would pass the mural every day."[3] Some six hundred thousand people annually traverse the WSU campus, where, fulfilling the artist's hope, they are able to encounter and marvel at this masterpiece.

Patricia McDonnell

1. Miró to Michel Leiris, August 10, 1924, quoted in Agnes de la Beaumelle, ed., *Joan Miró, 1917–1934* (Paris: Centre Pompidou, 2004), 148.

2. Margit Rowell, ed., *Joan Miró: Selected Writings and Interviews* (Boston: G. K. Hall, 1986), 294.

3. Ibid.

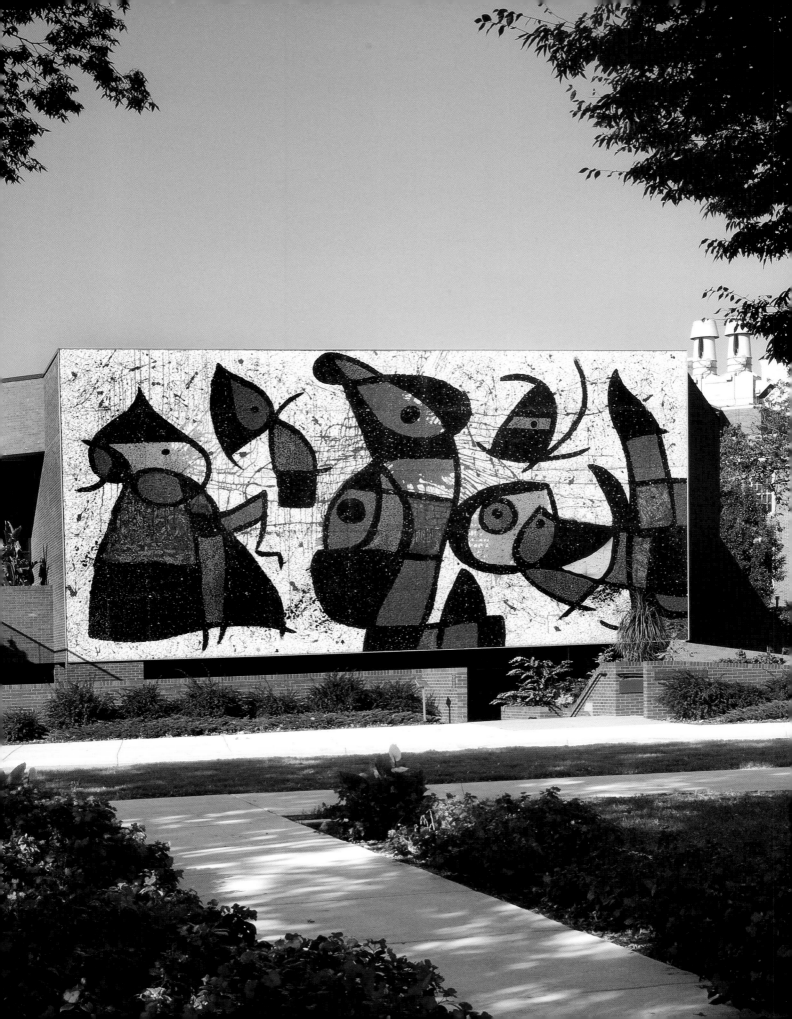

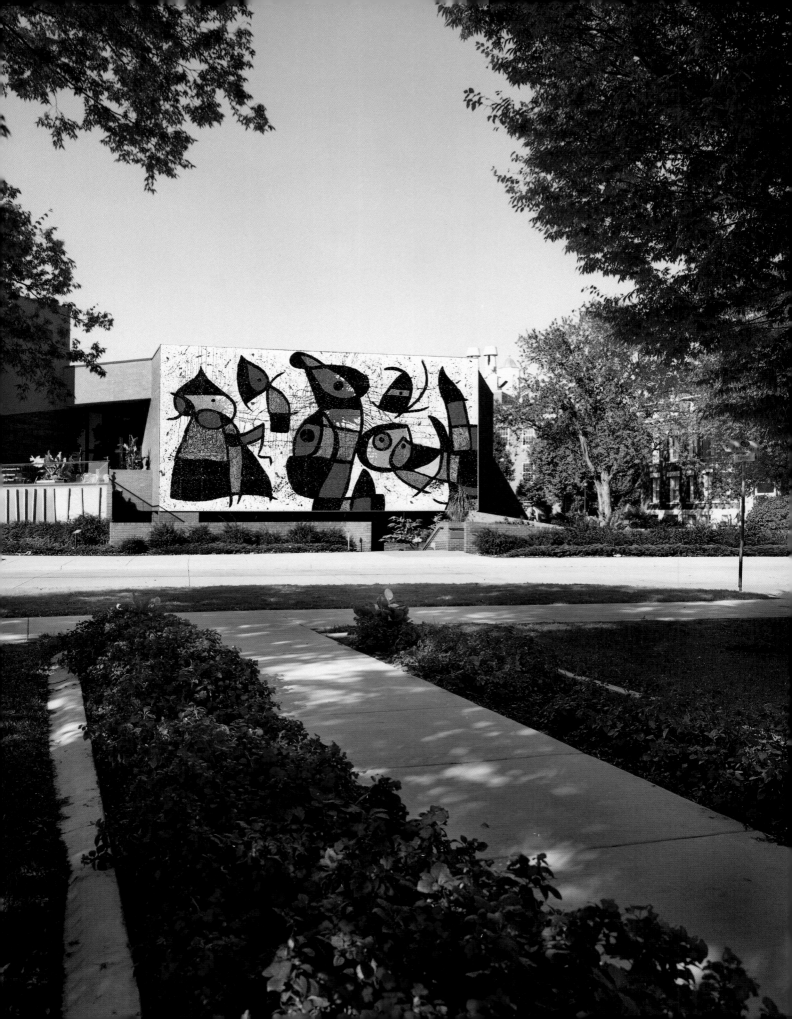

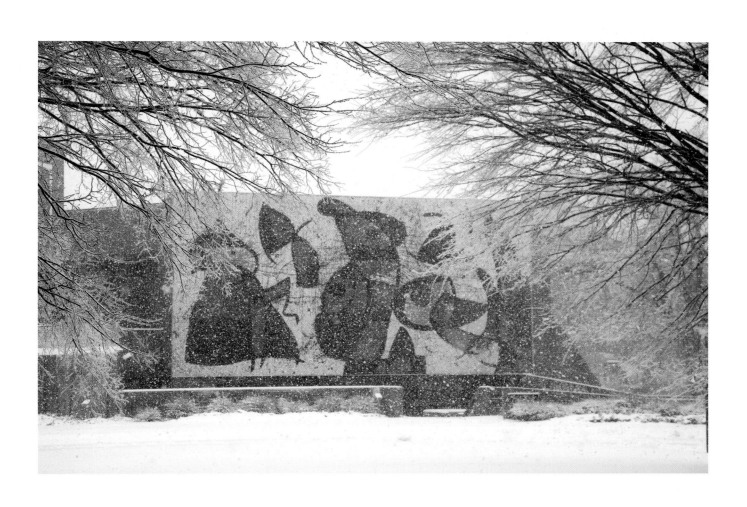

THIS WORK REPRESENTS A SIGNIFICANT CONFLUENCE IN PHOTOGRAPHIC HISTORY. When it was made, Eugène Atget was seventy years old and just a few weeks away from death. Berenice Abbott was a twenty-nine-year-old American expatriate in Paris and a relative beginner in photography. More than eighty years later, both of them are among the most revered contributors to this art form.

Born in Ohio and starting out as a sculptor, Abbott traveled in 1921 to Paris, where she worked as a studio assistant to the American photographer Man Ray. After gaining a grasp of basic photographic skills, she abandoned sculpture and opened a portrait studio. Abbott's photographs of Djuna Barnes, Jean Cocteau, and James Joyce, among others, are considered iconic images of the interwar period.

Man Ray introduced Abbott to Atget's photography. The older artist had cultivated a business that supplied images of Paris for reference purposes to local historical organizations, museums, artists, and designers. The painter Maurice Utrillo, for example, bought his photographs to serve as painting aids. Parisian surrealists admired how Atget could capture uncanny aspects of seemingly mundane scenes, and they saw a relationship between his work and their interest in finding the absurd within the commonplace. Ray had acquired Atget prints and shared them with Abbott, who noted how these sharply focused, unsentimental images of the French capital differed from the romantic subject matter and dreamy wistfulness of pictorialism, which was still the predominant mode of art photography.

In July 1927, Abbott obtained Atget's permission to take his portrait, and a session was arranged. She made three exposures: a standing view, a seated frontal view, and the profile that is in the Ulrich Museum collection. Atget died on August 4, before she could show her results to him. For the rest of her life, Abbott zealously pursued the preservation and promotion of his work. With contributions from friends, she purchased many of Atget's negatives and prints and so began making American photographers and collectors aware of his achievements.

As Abbott catalogued her new acquisitions, she came to see with increasing clarity Atget's singular ability to craft a photographic commentary on imperial-era Paris and its transition to a modern metropolis. In 1929 she returned to the United States to visit her family and passed through New York. She was so mesmerized by the city that she impulsively decided to put aside her well-established life in Paris and move to Manhattan. There, from 1929 to 1939, she concentrated on a project she called "Changing New York." Inspired by Atget's precedent, Abbott created an epic survey, remarkable for its sensitivity, wry humor, and exquisite design, of another intensely vibrant, multifaceted world capital as it lurched toward the future.

Patricia McDonnell

17 *Portrait of Eugène Atget*
1927
Gelatin silver print on paper, 13 1/4 x 10 1/4 in.
Museum Purchase, 1979.0005.001

18 *The Big Wheel*
1970
Gouache on paper, 29 ¹/₂ x 42 ¹/₄ in.
Gift of Mr. and Mrs. Sidney E. Cohn
1976.0031.001

Two critical leaders of modernism, Pablo Picasso and Henri Matisse, produced work at the end of their careers that elegantly encapsulated their individual aesthetic innovations. Similarly, *The Big Wheel*, made six years before the artist died, echoes Alexander Calder's earlier work while also reflecting his creative evolution over time.

Calder's initial fame depended largely upon his *Cirque Calder*, a traveling re-creation of a circus made of leather, wire, cloth, and other found materials. When he introduced the work, in Paris in 1926, the artist manipulated his fanciful figures so that they seemed to perform an impromptu big-top routine, which might last as long as two hours. Encouraged by this initial success, he made more wire sculptures, some of which represented celebrities such as the expatriated American entertainer Josephine Baker. These caricatures in wire are at once spontaneous and studied, witty and serious.

The bold colors and patterns of *The Big Wheel* vividly evoke the sense of standing inside a large circus tent and looking up. The white circle represents the hole at the top, and the swirled patterns in red, blue, gold, and black are the sewn-together tent sections. The black borders of the colored sections, reminiscent of the wire Calder used in numerous sculptures, animate the work, rather like spokes in a wheel.

Calder frequently incorporated actual motion into the kinetic sculptures he began fashioning in 1931. Initially, they moved in response to a hand crank or a small motor. By the time they were known as mobiles, Calder was constructing them so that their motion depended upon the circulation of air. Consisting of biomorphic, flat forms attached to wire and then to a metal spine, these randomly moving sculptures made no reference to the circus and seemed unrelated to the artist's earlier subject matter. The abstract quality of *The Big Wheel*, as well as the evocation of movement implied by both the title and the swirling forms, recall his kinetic sculptures.

Calder also created several sculptures for public buildings and outdoor spaces; these were so large that neither architecture nor nature could overshadow his work. Typically, he welded boldly colored, unadorned simple shapes onto a metal framework. The same shapes and colors he favored for his mobiles and sculptures are the basis for the two-dimensional *Big Wheel*.

Timothy R. Rodgers

Louise Nevelson has a place in the pantheon of modern sculptors of her generation, including Alexander Calder, Barbara Hepworth, Henry Moore, Isamu Noguchi, and David Smith – all born within the same decade (1898 to 1908). Her charismatic personality, however, nearly eclipses her contributions to sculpture. Known for her signature heavy mink eyelashes, eccentric outfits, and defiant self-confidence, she reveled in her status as a celebrity. Nevelson's playwright friend Edward Albee dramatized her life in the play *Occupant*, which premiered off-Broadway in 2002 with Anne Bancroft cast as the artist.

Born Leah Berliawsky in Kiev, she immigrated with her family to Rockland, Maine, in 1905. There, her father, who descended from a line of woodcutters, worked in the local lumberyard; interestingly, his daughter would employ wood as the primary sculptural medium for her signature works.

She married Charles Nevelson in 1920 and moved to New York, where she spent two decades pursuing various interests, including singing, dancing, acting, and painting. Nevelson studied at the Art Students League in 1929 and 1930, separated from her husband in 1931, and that year traveled to Munich to study with the painter Hans Hofmann. She took classes with him again in 1932, until the threat of Nazism impelled him to leave Germany and teach in New York.

Nevelson returned to America in the early 1930s and apprenticed to the Mexican painter Diego Rivera, assisting him, along with the artist Ben Shahn, on mural projects in Manhattan. Her association with Rivera and his wife, Frida Kahlo (they lived in the same building), fostered Nevelson's interest in the indigenous art of Mesoamerica.

Like many artists of her generation, Nevelson created abstracted forms to embody the notion of a universal and primal humanism. Her pedestal-top sculptures from the 1940s reflect the interest of various mid-century abstractionists in expressing profound truths through ancient myths – for example, the distorted pictographs of Adolph Gottlieb and primal figures of Jackson Pollock. At Manhattan's Sculpture Center, Nevelson worked in terracotta to produce the Moving-Static-Moving-Figures series (1946–48). She stacked combinations of biomorphic shapes on metal dowels and incised the surfaces of most of these elements to suggest ancient, rugged mythic personae. Edward Albee much appreciated the imaginative and suggestive "squat, blunt combination of a child's toy and prehistoric monument" in his friend's sculptures of this period.[1]

The stacking technique in the Moving-Static-Moving-Figures series may have inspired Nevelson's next phase, in the early 1950s, when she combined found wooden objects to create more sophisticated assemblages, most of which she painted a uniform black. Late in that decade, the artist's career took off, starting with her inclusion in the Museum of Modern Art's 1959 exhibition *Sixteen Americans*. Today, more than two decades after her death, Nevelson's artistic reputation rests on this later, signature style.

19 *Moving-Static-Moving-Figure*
1947
Painted terracotta, wood, and bronze
21 1/4 x 14 1/2 x 11 1/2 in.
Gift of Jerome B. Lurie, 1976.0035

Patricia McDonnell

1. Edward Albee, "Louise Nevelson: The Sum and the Parts," in *Louise Nevelson: Atmospheres and Environments*, exh. cat. (New York: Clarkson N. Potter in association with the Whitney Museum of American Art, 1980), 23–24.

20 *Arcanorum*
1966
Bronze, 22 1/4 x 18 1/4 x 13 1/4 in.
Gift of the artist in memory of Harold Weston
1974.77.0077

With experience I think the mystery of life, the wondrous mystery of nature, and the various things that enlighten us as we go through life, become more interesting, stranger, and more poignant.

Dorothy Dehner [1]

DOROTHY DEHNER BEGAN HER ARTISTIC CAREER IN NEW YORK AS AN ACTOR AND DANCER but decided to dedicate herself to the visual arts after discovering modern painting on a visit to Europe in 1925. Upon her return later that year, she enrolled at the Art Students League, where she studied with the Czech-born cubist painter Jan Matulka. She married a fellow art student, the sculptor David Smith, in 1927. Although they ultimately built an upstate home near Lake George, Dehner and Smith remained socially and professionally connected to Manhattan's avant-garde art world. She continued drawing and painting yet seemed to live in her husband's shadow, as his abstract sculptures began receiving acclaim. Not until the couple divorced, in 1952, did Dehner actively add three-dimensional work to her repertoire.

Dehner's sculptures seem at once both elemental and talismanic. Working directly with slabs of wax, she cut, shaped, and assembled various geometric forms, which she then incised with distinctly personal markings before casting them in bronze. Her memories of places, both familiar and foreign, often informed these intuitive, asymmetrically balanced, abstract arrangements. In the 1960s, she drew inspiration from sketches she had made in museums and at archaeological sites in Greece on a 1935 trip there. She based sculptures with titles such as *Midas*, *Knossos Inhabited*, *Minotaur*, and *Demeter's Harrow* on these decades-old drawings; at least two share the title *Arcanorum*, which is Latin for "of secrets" and reflective of Dehner's abiding interest in the mythic and mysterious.[2] Crafted of round and rectangular forms and marked with enigmatic circles and crosshatches, this 1966 version evokes both a cluster of figures and archaeological ruins.

Emily Stamey

1. Dehner interviewed by Elizabeth de Bethune in "Dorothy Dehner," *Art Journal* 53, no. 1 (Spring 1994): 36.

2. Another Dehner *Arcanorum* (1960) is reproduced in Dorothy Keane-White, *Dorothy Dehner: Sculpture and Works on Paper*, exh. cat. (New York: Twining Gallery and Allentown, Pa.: Muhlenberg College, 1988), 25.

"The beauty of the past belongs to the past. It cannot be imitated today and live," Margaret Bourke-White wrote in 1928.[1] This photograph of a radio microphone, a key image in one of her most ambitious projects, exemplifies her belief that contemporary subjects should be represented in a contemporary style. The image is part of an enormous photomural for the rotunda of the NBC studios in the RCA Building in New York's Rockefeller Center that was installed in December 1933 and removed and presumably destroyed in 1953 or 1954. Bourke-White called photomurals "a new American art form," and as an ambitious, entrepreneurial commercial photographer, she championed their use in corporate décor.[2]

Alfred Stieglitz told Bourke-White that she "saw big," meaning her pictures could be enlarged with no loss of power.[3] Her gift is evident in what is likely her best-known photograph, that of the immense Fort Peck Dam, for the cover of the first issue of *Life* magazine in November 1936. But her ability to confer a sense of monumentality was equally evident in the NBC photomural. At the time, it was the world's largest: 160 feet in circumference, with images ten feet, eight inches high. The mural was executed in two sections, with the microphone image at the center of one and a picture of tubes at the center of the other, each flanked by pictures of other electronic components and transmission towers. The installation created a dynamic sequence suggestive of a cinematic montage, tracing the movement of the radio signal from recording microphone through transmission to loudspeakers.

21 *NBC Radio – Microphone*
1935
Gelatin silver print on paper
12 x 13 7/8 in. (sheet); 10 1/2 x 13 1/4 in. (image)
Museum Purchase, 1984.0015.005

The designs of several other images in the mural are based on repetition; for example, multiple components such as speaker elements are arranged in an almost abstract pattern. In contrast, the microphone picture provides a straightforward record of functional and symmetrical – if oddly intricate – geometry, emphasizing the prominent NBC logo, complete with lightning bolts. Yet for all its directness and simplicity, the image also reveals Bourke-White's subtlety and skill: the rays of light fanning out in the background provide contrast while adding visual flair.

Bourke-White began her career by specializing in photographs of modern industry – specifically, the steel mills of Cleveland, with their powerful architecture and dramatic displays of fire and molten metal. Later, she became known as a photo-journalist, recording the horrors of war and the plight of the impoverished. She also took memorable pictures of world figures such as Gandhi.

The NBC photomural reflected the transition from the industrial revolution to the rise of electronic media. It also offered a fitting tribute from one modern medium to another, a visual homage to the power of sound. Although that early moment in the electronic age may seem, like the microphone itself, almost quaint, this photograph remains an indelible expression of Bourke-White's ability to create images that display a modern sense of beauty.

Robert Silberman

1. Bourke-White diary, May 11, 1928, quoted in Vicki Goldberg, *Margaret Bourke-White: A Biography* (Reading, Mass.: Addison-Wesley, 1987), 89.

2. Bourke-White, "Color Photography in Advertising," speech to New York Times Advertising Club, February 16, 1934, quoted in Melissa A. McEuen, *Seeing America: Women Photographers between the Wars* (Lexington, Ky.: University Press of Kentucky, 2000), 227.

3. Stieglitz quoted in Goldberg, *Margaret Bourke-White,* 143.

DUBBED THE "PARK AVENUE CUBISTS" BECAUSE OF THEIR COLLECTIVE WEALTH, George L. K. Morris, his wife, Suzy Frelinghuysen, and friends A. E. Gallatin and Charles B. Shaw were committed advocates of abstract art throughout their careers.[1] During the 1930s and 1940s, many critics, the general public, and even fellow artists dismissed American abstraction as being derivative of European forms. Instead, they encouraged the development of art that drew upon indigenous American culture, identity, and spirit. By contrast, Morris's paintings made obvious reference to cubism, particularly synthetic cubism – a visual language, mainly developed by Pablo Picasso, that yielded paintings with fragmented, overlapping forms that seemed almost collaged onto the canvas – as well as other European movements associated with the artists Jean Arp, Juan Gris, and Fernand Léger.

In response to criticism, Morris established the French-English magazine *Plastique* in 1937 as a vehicle to promote abstract art and ideas related to it. Also, in 1940 he and several other artists picketed the Museum of Modern Art for its refusal to show the works of fellow American abstractionists. They rejected the notion that all works of American art should spring from a wholly original, and native, sensibility. Instead, Morris and like-minded abstractionists insisted that all great artists borrow aesthetic ideas from those who precede them, regardless of their predecessors' nationality.[2]

The energetic, collagelike style of *Unequal Forces, No. 2* evokes the hard-edged cubism of Stuart Davis. Morris presents a central form divided into numerous overlapping cutout shapes, some of which bear flat graphic patterns. By repeating the colors red, black, tan, and white, the artist imbues this work with a lively, almost jazzy rhythm.

22 *Unequal Forces, No. 2*
1947
Oil on canvas, 37 x 54 in.
Gift of the artist in memory of
Harold Weston, 1974.0042

Around the time Morris made this painting, a group of New York–based artists soon to become known as abstract expressionists were creating paintings based on their interpretation of European developments in abstraction. Unlike Morris, they were less obvious in their references to European influences, and as a result, influential critics hailed their work for its ostensible celebration of qualities perceived as inherently American.

Timothy R. Rodgers

1. For this circle of artists and their efforts to advance the abstractionist cause, see Debra Bricker Balken and Deborah Menaker Rothschild, *Suzy Frelinghuysen and George L. K. Morris: American Abstract Artists, Aspects of Their Work and Collection*, exh. cat. (Williamstown, Mass.: Williams College Museum of Art, 1992).

2. For the intersection of abstract art and Native American symbolism in works by the Park Avenue abstractionists, see Jackson W. Rushing, *Native American Art and the New York Avant-Garde* (Austin: University of Texas Press, 1995).

23 *Still Life*
1938
Oil on canvas, 38 × 30 ¼ in.
Gift of Rosalind Browne, 1976.0024

The Great Depression was in full swing. Contemplating going into the arts as a lifetime profession was the ultimate in an irrational hope and a guarantee of economic and social suicide. Then, of all things, to choose an area of interest . . . that was so coldly received as was abstract painting was yet another step into the twilight zone.

Ed Garman [1]

ABSTRACTION ENTERED THE REALM OF PAINTING SHORTLY AFTER 1900, BUT ITS INITIAL POPULARITY WANED IN THE WAKE OF WORLD WAR I. The brutalities and massive losses of the Great War fostered a reemergence of conservative tendencies, and pioneering abstractionists – from the Europeans Pablo Picasso and Kasimir Malevich to the Americans Arthur Dove and Georgia O'Keeffe – shifted to representational modes in the 1920s. Among the courageous and defiant few who continued to express themselves through abstraction was the New York artist Byron Browne.

From 1925 to 1928, Browne attended New York's traditionalist National Academy of Design, where his work won prizes. Near the end of that time, he discovered the Gallery of Living Art at New York University – opened in 1927 by the connoisseur and painter A. E. Gallatin to show his international collection of avant-garde art – and quickly converted to abstraction. He became a founding member of the American Abstract Artists (AAA), an exhibiting organization formed in 1936 to advocate for and promote understanding of nonobjective art. In those lean Great Depression years, Browne relied upon mural commissions that his fellow AAA member Burgoyne Diller, then serving as director of the Works Progress Administration's New York Mural Division, steered his way. Browne executed five murals during the 1930s.

Still Life typifies Browne's efforts of that period. Occasionally, his compositions bear no resemblance to actual objects. But more often, as here, the imagery is abstracted. The animated jumble of elements and colors recalls the flat patterning of synthetic cubism and the biomorphic forms of surrealism. The syncopation across the canvas of vibrant versus muted colors and motifs contributes to a strong pictorial cohesion, despite the composition's nervous energy. The still-life references – a floral spray at the upper left and circular fruit forms at the center – are not immediately apparent but emerge upon closer observation. *Still Life* is a representative example of the bold modernism that certain tenacious American artists produced in the turbulent 1930s.

Patricia McDonnell

1. Artist Ed Garman to Virginia Mecklenburg, February 15, 1988, curatorial files, Smithsonian American Art Museum, Washington, D.C.

24 *Muhammad Ali on Staircase*
1966
Gelatin silver print on paper
14 x 11 in. (sheet); 14 x 9 ½ in. (image)
Museum Purchase, 2008.0026

ALTHOUGH HIS NICKNAME HAS LONG BEEN "THE GREATEST," MUHAMMAD ALI HAS NOT ALWAYS GARNERED FAVOR. In the winter of 1966, the young world heavyweight-boxing champion began drawing public scorn for opposing the Vietnam War. Having changed his name from Cassius Clay after joining the racially separatist Nation of Islam in 1964, he resisted the military draft, citing his religion. "Those Vietcongs are not attacking me," he declared. "All I know is that they are considered Asiatic black people, and I don't have no fight with black people."[1] Many in the press criticized him, doubting both his intelligence and the sincerity of his stance as a conscientious objector. In response, Ali became increasingly outspoken and confrontational.

Gordon Parks, *Muhammad Ali*, 1966.
Gelatin silver print, 14 x 11 in. Museum
Purchase, 2008.0023.

That spring, *Life* magazine sent staff photographer Gordon Parks to meet and profile Ali. The child of poor black tenant farmers in Fort Scott, Kansas, Parks was a self-taught photographer who often used his talents to dramatize and combat poverty, racism, and other social ills. Although he disagreed with Ali on many counts, he sympathized with him on others, and over several months the two forged a friendship. Parks recounted their interactions in a September article in *Life* that featured a now-iconic photograph of a tense, sweat-drenched Ali. "Muhammad was a gifted black champion and I wanted him to be a hero," he wrote, articulating his initial ambivalence about the boxer, "but he wasn't making it."[2]

Further along in the article, presciently titled "The Redemption of the Champion," Parks described, in an almost fatherly tone, their discussions about the public's troubled perception of Ali. He also wrote about a press conference after a London fight at which Ali impressed him and others by apologizing for past indiscretions: "I said things and did things not becoming of a champion." Having watched Ali keep his resolve to behave like "a gentleman" following that apology, Parks closed the article this way: "At last, he seemed fully aware of the kind of behavior that brings respect. Already a brilliant fighter, there was hope now that he might become a champion everyone could look up to."[3]

Parks probably took this photograph, which was not included in the *Life* article, in London that summer. Neatly attired in slacks and a jacket, Ali stands bracketed not by the ropes of a boxing ring but by a stairwell's elegant scrollwork and a gilded historic portrait. Head tilted, he gazes contemplatively out beyond the frame of the image, as light falls across his features. Carefully aligning dress, setting, and pose, Parks captured the young Ali as the gentleman he was striving to become.

Emily Stamey

1. Ali quoted in Tom Fitzpatrick, "Cassius Appeals: 'Muslims Not at War,'" *Chicago Daily News*, February 18, 1966.

2. Gordon Parks, "The Redemption of the Champion," *Life*, September 9, 1966: 79.

3. Ibid, 84.

The Ulrich's collection includes twenty-three Parks photographs.

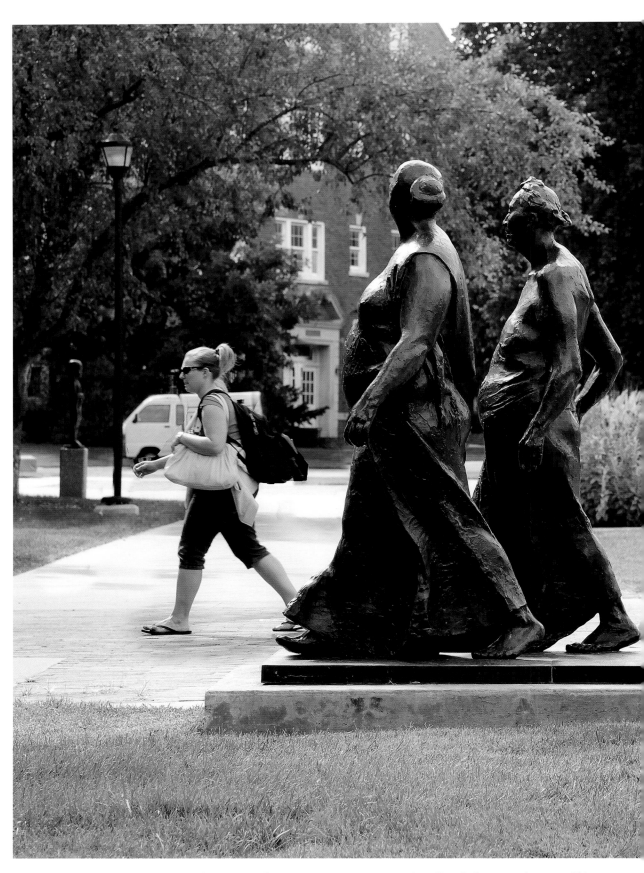

Francisco Zúñiga, (Mexican, 1912–1998), *Three Women Walking,* 1981. Bronze, 76 x 101 x 45 in. (overall). Gift of George and Virginia Ablah, 1986.0006.

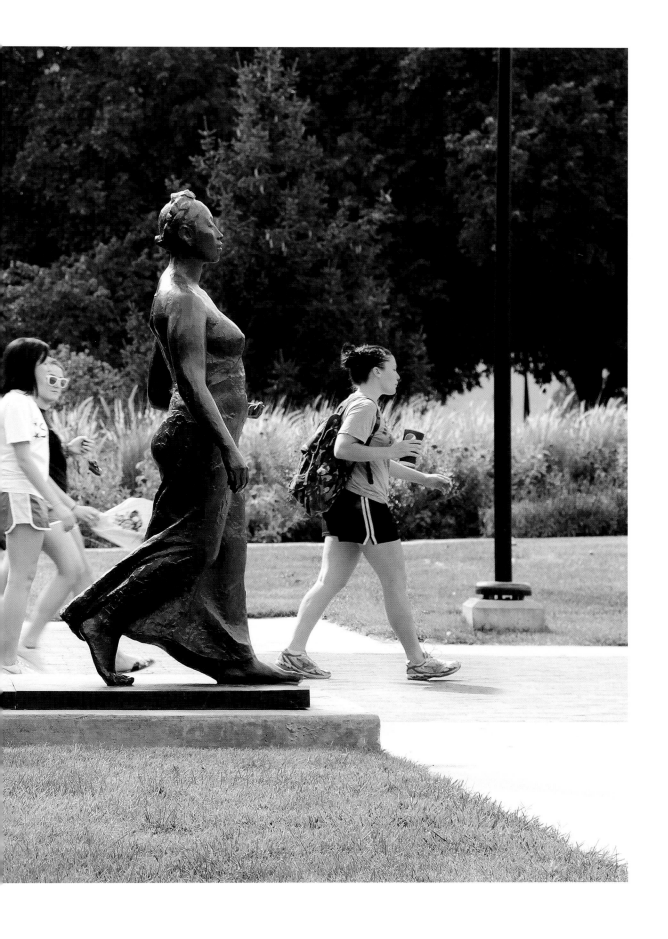

25 *Les Caves No. 2* (**The Cellars No. 2**)
1976
Acrylic on canvas, 72 x 144 in.
Museum Purchase and Gift of the Dedalus
Foundation, 1994.0036

IN THE 1940S, ROBERT MOTHERWELL WAS PART OF THE GROUP OF ARTISTS – INCLUDING WILLEM DE KOONING, JACKSON POLLOCK, AND MARK ROTHKO – known as abstract expressionists. Dismissing realism as an inadequate means of expressing themselves through art, they pursued various forms of abstraction. Particularly inspired by the European surrealists' emphasis on tapping the subconscious, they sought freely and with immediacy to convey not the *objective* realities of the visible world but their *subjective* reactions to those realities.

Regarded as the intellectual of the group, Motherwell attributed his erudition to extensive foreign travel and his study of philosophy, literature, psychology, and world history. Throughout his long career, he often alluded to these subjects in the titles of his abstract paintings – for example, *In Plato's Cave* and the extensive series Elegy to the Spanish Republic.

The year before Motherwell painted *Les Caves No. 2*, Baron Philippe de Rothschild commissioned him to create a work that would hang in the family museum in Bordeaux, France, and also be reproduced on the label of a vintage of the renowned Rothschild wine. Motherwell made a small sketch, titled *Les Caves*, which inspired a larger painting. He explained how this circumstance informed the titles of both works:

> Wine naturally makes one think of cellars and the French word for cellar is cave. This word brings to mind the English word cave. Cave in turn brought to the fore my memories of Lascaux and Altamira, of a tenth-century Saracen description of the barbaric Viking settlements on the Volga, of the antiquity of grapes and wine and the good earth – the caves in the Dordogne in France are friendly and warm, as they are north of Madrid, not damp and ominous as they are in other parts of the world. But since I called the Rothschild sketch Les Caves, its enormous successor could only be called, looking at it, the same thing. Thus, I named it Les Caves No. 2.[1]

The range of subjects Motherwell brings together here – from prehistoric cave paintings in France and Spain, to a medieval Arabic account of Scandinavian communities in Russia, to the centuries-old tradition of wine making, to a comparison of global climates – demonstrates both his breadth of knowledge and how free association was a critical aspect of his art.

Emily Stamey

1. Motherwell quoted in H. H. Arnason, *Robert Motherwell*, 2nd ed. (New York: Harry N. Abrams, 1982), 97.

26 *Study in Automatism*
1976–77 (initialed and dated on the image:
RM 76; signed and dated on the reverse:
R Motherwell January 1977)
Acrylic and china marker on canvas, 16 x 20 in.
Museum Purchase and Gift of the Dedalus
Foundation, 1994.0038

PROMOTED BY THE EUROPEAN SURREALISTS, AUTOMATISM – OR "PSYCHIC AUTOMATISM," AS THE FRENCH WRITER ANDRÉ BRETON INITIALLY CALLED IT in *The Manifesto of Surrealism* (1924) – ostensibly provided access to an individual's unconscious. If effective, automatism would enable the visual artist to produce images and gestures both personal and original, uncensored by style or other rational frameworks.

During World War II, a number of surrealists found safe haven in New York. There they encountered the circle of young American artists who, after the war, would become known as the abstract expressionists. Most members of this group enthusiastically embraced automatism. Formally schooled in philosophy and fascinated by psychology, Robert Motherwell became especially engaged in discussions about the theoretical and practical potential of automatism.

Throughout his career, which began in the early 1940s, Motherwell spoke eloquently and wrote lucidly about the importance of automatism to his own work and to modern art in general. He expressed his commitment to the concept in a 1978 letter to Edward Henning, then curator of modern art at the Cleveland Museum of Art: "I believe it is the most powerful creative principle – unless collage is – consciously developed in twentieth-century art. The intelligent and honest use of it can only lead to the originality and to, of course, the limitations of one's own beingness." [1]

In the margins of that letter, Motherwell commented that collage – the assemblage of disparate elements – might be as important as automatism, since it "is also partly free-association" and therefore includes its own elements of automatism. Those words, written a year after he completed *Study in Automatism*, illuminate Motherwell's intent. In the work, dense areas of flat black paint abut zones of ochre and pale blue, across which drawn black lines curve and cut. The combined effect evokes collage: numerous gestures intuitively pieced and layered together.

Emily Stamey

1. Motherwell to Edward Henning, October 18, 1978, transcribed in Stephanie Ternzio, ed., *The Collected Writings of Robert Motherwell* (New York and Oxford: Oxford University Press, 1992), 230.

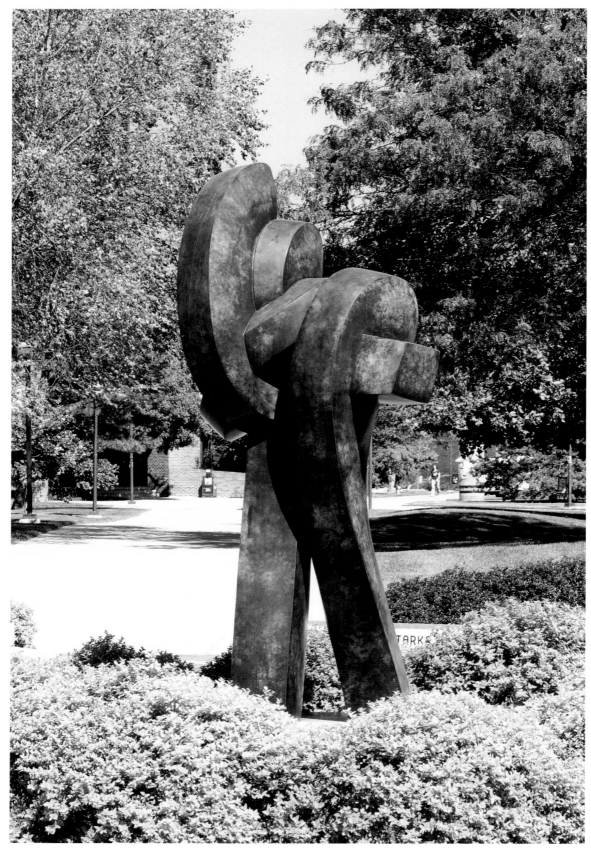

Sophia Vari (Greek, born 1940), *Danseuse Espagnole*, 1992. Bronze, 100 x 44 x 44 in. Museum Purchase, 1998.0047.

George Rickey (American, 1907–2002), *Two Lines Oblique Down, Variation III*, 1970. Stainless steel, column: 252 in., blades: 180 in. each. Museum Purchase with Student Government Association funds, 1972.0039.

ONE OF THE FIRST AFRICAN AMERICAN ARTISTS TO ACHIEVE WIDESPREAD NATIONAL ACCLAIM, THE PAINTER JACOB LAWRENCE WAS A KEEN OBSERVER OF AMERICAN CULTURE and a committed storyteller. While still in his teens, he took classes at the Harlem Art Workshop, which operated as part of Franklin D. Roosevelt's Works Progress Administration, and later studied at the Harlem Community Art Center. Lawrence both learned from and participated in the Harlem Renaissance of the 1920s and 1930s, during which African American art, literature, music, dance, and social commentary flourished. Developing a distinct, modernist approach to history painting, he dedicated himself to illustrating the stories of blacks from the Civil War up to his own day.

Lawrence animated these stories with expressively simplified and energetic figures executed in rich, often primary, colors, and he worked frequently in a series format – each narrative advancing through successive paintings. The series that first brought him national attention and remains his most famous project was The Migration of the Negro, which he completed in 1941 at age twenty-three. In sixty small paintings, it told of the large-scale movement of African Americans from the rural South to the urban North after World War I.

In addition to producing forthrightly historical narratives, Lawrence explored broader, more symbolic themes. He was especially intrigued by labor in its many forms, and he frequently portrayed people working – for example, doing laundry, teaching, painting, repairing radios, mining, shelving library books, cooking, or performing surgery.

27 *Black Cowboys*
ca. 1967
Casein tempera on illustration board
20 x 30 in.
Museum Purchase, 1998.0052

In the late 1960s, he focused particularly on scenes of construction workers, subject matter to which he repeatedly returned until the end of his life. Collectively known as The Builders, these paintings of men and women working with wood and tools of the building trade are among the artist's most iconic images.

Black Cowboys reflects Lawrence's dedication to both history painting and labor imagery. Although their contributions are often overlooked, African Americans were instrumental in settling the American West, a fact the artist celebrates in this depiction of two black men driving cattle. A 1998 letter from his art dealer to the Ulrich indicates that Lawrence wanted the painting to live in a museum that had geographic and historic links to its content.[1] No doubt he considered Wichita, which first thrived as a cattle town, to be a fitting home for this colorful and lively work.

Emily Stamey

1. Joseph S. Cooper to Donald Knaub, Director, Edwin A. Ulrich Museum of Art, June 17, 1998, Ulrich Museum of Art object file.

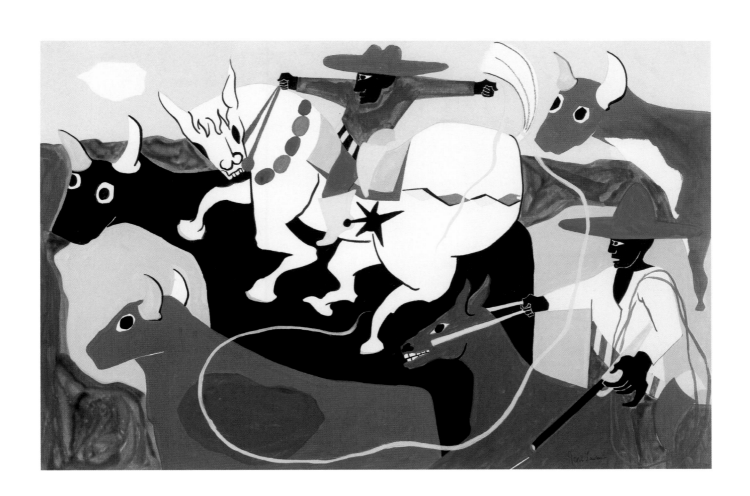

W. Eugene Smith (American, 1918–1978)

28 *Frontline Soldier with Canteen, Saipan*
1944
Gelatin silver print on paper, 13 ¼ x 10 ½ in.
Museum Purchase, 1978.0010.001

W. EUGENE SMITH WANTED HIS GRAPHIC WAR PHOTOGRAPHS TO SHOW PEOPLE THE TRUTH ABOUT WAR AND CHANGE THE WORLD:

> *I would that my photographs might be, not the coverage of a news event, but an indictment of war – the brutal corrupting viciousness of its doing to the minds and bodies of men; and, that my photographs might be a powerful emotional catalyst to the reasoning which would help this vile and criminal stupidity from beginning again.*

A naive view, perhaps, even if Smith was not the first – or the last – photographer to hold it. It is unlikely, however, that anyone ever acted upon that belief with quite the same passion. Arguably the greatest of all photojournalists, Smith photographed World War II with wild intensity and unrivaled skill. He produced images that continue to serve as one measure of war photography, and he has a secure place in that long line of masters from the Civil War photographers associated with Mathew Brady through Robert Capa and David Douglas Duncan to Donald McCullin and James Nachtwey.

The war in the Pacific was, to borrow from the philosopher Thomas Hobbes, nasty and brutish – but not short. This image is from the island of Saipan, where Smith later took other powerful pictures during mop-up operations, including one of a terrified mother and son trapped in a cave and then flushed out, trying to escape "when there was no escape." In another, a GI holds a baby; Smith observed, "Unfortunately, it was alive. We hoped it would die." [2]

Here, Smith worked up close, capturing two soldiers in a simple, strong composition. Whatever his general feelings about war, Smith, like his friend the war correspondent Ernie Pyle, was sympathetic toward regular enlisted men and tried to portray them with "compassionate understanding." [3] This shot suggests pure need, pure thirst, with the intensity of combat implied by the intensity of a brief respite. The drinking soldier is sharply rendered, set against the slightly out-of-focus but still forceful presence of the soldier looming behind him. This image is all about immediacy, with the camera recording gesture and expression – emphasizing physical details, such as the unshaven face, the grit, the sweat, and, above all, that drink of water.

Smith was seriously wounded in May 1945, during the invasion of Okinawa, and his photographic tour of duty was over. Still recovering a year later, he took a picture of his two small children on a woodland path, emerging from darkness into light. *The Walk to Paradise Garden* (cat. no. 29) attained international fame after serving as the final image in the blockbuster 1955 touring exhibition *The Family of Man* and its accompanying book. But that was later and worlds away. The Saipan photograph offers no hint of that vision of what Smith called "a gentle moment of spirited purity." [4] In portraying a break from combat, it keeps us focused on the men without losing sight of the war.

Robert Silberman

1. Quoted in Lincoln Kirstein, "W. Eugene Smith: Success or Failure, Art or History," in W. Eugene Smith, *W. Eugene Smith: His Photographs and Notes* (New York: Aperture, 1969), n.p.

2. Ibid.

3. Ibid.

4. Ibid.

The Ulrich's collection includes twenty-two Smith photographs.

29 *The Walk to Paradise Garden*
1946
Gelatin silver print on paper, 12 x 10 ¼ in.
Museum Purchase, 1978.0010.002

THROUGH A RAGGED, HEART-SHAPED PATCH OF LIGHT THEY STEP, a couple whose hands must be clasped. Are they going in or coming out? They are too young, certainly, and poorly prepared for night or cold. They've dressed themselves inadequately; they carry no useful tool or weapon, no provision – no umbrella, no compass, no picnic basket. Where are the adults?

They are the dreamed inhabitants of a bedtime story, conjured by a listening child, inspired by a tired parent telling a tireder tale: the princess and the prince. The difficult journey. The thorns and wolves and witches and woe that wait in the woods, the many enemies of love and light and goodness. Et cetera, yawning ad nauseam. The narrating parent is distracted by her own intoxicating thoughts: television, red wine, a lingering argument with the spouse, the prickling temptation of infidelity, an incendiary glance, an extended hand.

Meanwhile, the child burrows into her cave made of imagination and linens, satin and fantasy, pink and pure, the prince and princess stepping boldly into their adventure. They are at the mercy of weather, ill will, and time itself. They are at the mercy of their bored teller, who is putting herself to sleep. Their only defense is a pair of linked hands and the fertile busy mind of desire. The lonesome child can see it all – happy flowers, ripe berries, birds bearing bright messages for the lucky couple. They will be resourceful, courageous, brilliant, and triumphant.

They have come from darkness; they will return to it. They have only each other, and that is enough – a vow taken on a wedding day, a wax ornament on a wedding cake, faith like a shared leap from one void into another.

In or out: it doesn't matter. If they are together, un-alone, it cannot matter. In between darknesses, there is the blessed and blinding and forgetful light.

Antonya Nelson

I GOT MY FIRST DOG RIGHT OUT OF COLLEGE. I'd been struggling socially, adjusting to adult life: a full-time job, older colleagues, a long commute. Most of my friends had moved away after graduation. I lived near a park where people took the leashes off their golden retrievers and Labrador retrievers, their Frisbee-catching border collies. While the dogs frolicked, the owners talked. They knew the names of one another's dogs. It seemed a club anyone could join.

I don't recall the other dogs at the pound. I only remember the one I chose: a tail-thumping German shepherd trying to avoid the poop on the floor of her cage. The volunteer reached through the bars to pet her head.

"They found this one dragging a padlock and a chain around, skinnier than she is now."

Attached to the door of the cage was a note: "Due to lack of space, this dog may be destroyed after *July 3rd*."

"Is she friendly?"

"I think so. Especially for a shepherd."

At first, all was well. Rita was playful, attentive, and quickly housebroken. I took her to the park, and she frolicked with other dogs while I chatted with other owners. But the dog park proved to be just a bonus; it turned out that I liked having Rita around, nuzzling my nose in the morning, dancing in circles when I walked in the door. She seemed delighted with her now-abundant food supply. She bulked up quickly. When I walked her on the leash, strangers commented on her beauty. But people with children pulled them close as Rita and I approached.

She never attacked a child. I like to think she understood that would have been her undoing. But she did start getting in unprovoked fights with other dogs. I tried training, management, and scolding. She got worse. After I paid a vet bill for an eyelid injury Rita inflicted on a pug, I knew there was only one solution, or one solution I could accept: Rita could not have access to other dogs. Ever. At the time, I didn't have a yard, so I walked her on a strong leash, avoiding the dog park and avoiding people with dogs. My plan to become more social by getting a dog had backfired, to say the least. Whenever an unleashed dog bounded toward us, I tightened the leash and stepped in front of Rita, warning the other dog away and saying to the owner, "Get back! Get it away!" Rita developed the creepy habit of wagging her tail at a dog before attempting to attack, and so to other owners, owners of normal dogs, I looked crazy.

30 *Lady Bartender at Home with a Souvenir Dog, New Orleans*
1964 (printed later)
Gelatin silver print on paper
20 x 16 in. (sheet); 14 ¼ x 14 ¼ in. (image)
Museum Purchase, 2002.0016

"They can sense your energy," opined a soft-voiced woman in a flowing skirt. She was walking with friends, her unleashed Lab happy beside her. "You know? Maybe if you chilled out a little, she would, too."

Maybe, Lab woman – you who perhaps know more of metaphysics than of desperate, unconditional love. Maybe I made my dog neurotic. Or maybe – and I've known a few parents who would agree – sometimes you get what you get, love it anyway, and do the best you can.

Laura Moriarty

31 *Untitled*
1956
Oil on canvas, 84 × 77 in.
Gift of Clay Felker, 1977.0037

Blue is an eternal color
It means infinite bliss
When it turns to black

I turn my back and go away
To blue the eternal color
When it turns to red I pray […] [1]

SLIGHTLY TALLER AND WIDER THAN AN AVERAGE MALE MUSEUM VISITOR STANDING WITH HIS ARMS OUTSPREAD, Joan Mitchell's *Untitled* engulfs the viewer in an energetic lattice of red, blue, black, green, and brown brushstrokes. Varying dramatically in opacity and color saturation, her loose, often drippy marks move from vertical to horizontal to diagonal, and they coalesce into and dissolve out of intricate knots. As the above verses from Jim Brodey's poem "Joan Mitchell" suggest, her paintings evoke psychological states rather than depict recognizable subjects.

Mitchell is closely associated with abstract expressionism. Developed in New York in the late 1940s by painters who included Willem de Kooning, Arshile Gorky, Franz Kline, and Jackson Pollock and given a theoretical framework by the influential critic Clement Greenberg, this new form of "nonobjective" painting was characterized by the exuberant application of paint to express primal states of being. Although she frequented the studios of de Kooning, Gorky, and Kline and was a regular at their favorite Greenwich Village watering hole, the Cedar Tavern, Mitchell belonged to a younger, second generation of abstract expressionists who expanded the concept of pure abstraction.

Asked why he didn't work more from nature, Jackson Pollock famously declared, "I am nature!" [2] Mitchell, however, never subscribed to the existential and self-referential tenets of abstract expressionism, instead remaining closely connected to the physical world. "I'm very old-fashioned but not reactionary," she explained. "My paintings aren't about art issues. They're about a feeling that comes to me from the outside, from landscape." [3] Like her early influences, Paul Cézanne and Wassily Kandinsky, artists who sought new ways to express impressions of the world in painterly form, Mitchell attempted to translate subjective sense memories through the objective medium of paint on canvas. "I paint," she once wrote, "from remembered landscapes that I carry with me – and remembered feelings of them, which of course become transformed. I could certainly never mirror nature. I would like more to paint what it leaves me with." [4]

The art historian Marcia Tucker characterized Mitchell's work as "private, vulnerable, full of the energy of madness and genius, elegance and unparalleled physical intensity." [5] *Untitled* dynamically expresses, and balances, the qualities Tucker identified.

Toby Kamps

1. Jim Brodey, "Joan Mitchell," in Brodey, *Heart of the Breath: Poems, 1979–1992* (New York: Hard Press Editions, 1996), 121.

2. Dorothy Seckler, "Oral history interview with Lee Krasner, 1964 Nov. 2–1968 Apr. 11," Archives of American Art, Smithsonian Institution, Washington, D.C. Available online at www.aaa.si.edu/collections/oralhistories/transcripts/krasne64.htm. Accessed October 11, 2009.

3. Mitchell quoted in Marcia Tucker, *Joan Mitchell*, exh. cat. (New York: Whitney Museum of American Art, 1974), 6.

4. Mitchell letter, quoted in John I. H. Baur, *Nature in Abstraction: The Relation of Abstract Painting and Sculpture to Nature in Twentieth-Century American Art* (New York: Whitney Museum of American Art, 1958), 75; as cited in Judith E. Bernstock, *Joan Mitchell* (New York: Hudson Hills Press, 1988), 31.

5. Tucker, *Joan Mitchell*, 16.

ARMAN HELPED PIONEER A PARADIGM SHIFT IN THE ART WORLD OF THE 1950S AND 1960S. He was part of a generation that rejected the abstract expressionism then favored by critics and collectors. Instead, he and his contemporaries developed distinctive artistic practices that celebrated chance and change, the raw energy of the street, the consumer marketplace, and mass-media advertising – in short, the pulse of quotidian experience in the mid-twentieth century.

Born Armand Pierre Fernandez in Nice, France, he decided to use his first name only in the late 1940s; and a typesetting error on the cover of an exhibition catalogue in 1958 prompted him to drop the *d* and style himself simply as Arman. His father owned an antique and used-furniture store. The fact that he grew up surrounded by material objects no doubt influenced his art.

Arman was a leading light in *Nouveau réalisme*, a movement of young, mostly French artists formed in 1960 that also included Yves Klein, Daniel Spoerri, and Jean Tinguely, among others, as well as the critic Pierre Restany. Collectively, they sought a stark objectivity, a broader, dadaist-inspired definition for art, and a wholehearted embrace of modern-day mass culture. *Achilles Syndrome* (acquired from his 1977 one-person exhibition at the Ulrich Museum) is one of the artist's signature "accumulations," a primary mode of production in his oeuvre. Bemused by consumerist excess and the deification of objects, Arman fused together large quantities of the same commonplace item – in this case, identical shoetrees arranged to resemble a foot. Some of his other notable accumulations featured pliers, axes, teapots, doll parts, gas burners, car hoods, and telephone receivers.

32 *Achilles Syndrome*
1976
Wooden shoe forms, metal screws, and acrylic paint, 19 ¹/₂ x 59 x 30 in.
Gift of the artist, 1979.0010

Arman and other *Nouveau réalisme* artists have often been associated with their American pop art contemporaries, and certainly a fascination with mass culture links them. Distinct differences exist, however, as Arman made clear:

> As I evolved into object art, I found myself being called a pop artist. But the term isn't exactly right. Pop artists redo the object. I use the real object. Marcel Duchamp, who is the obvious father of object art, might have taken a soup can and put it on a red pedestal. [Andy] Warhol would repaint the soup can. [Jasper] Johns would cast it in bronze. I'd take the soup can and cut it into pieces or weld hundreds of them together in order to change the state of the object from what it was when you first saw it in the supermarket. My interest is in exploring the various worlds of the object.[1]

The Ulrich's collection includes another Arman work, one of his numerous *coléres*, or tantrums – smashed or burned common objects, typically bearing strong cultural associations. *Final Accord* (1981), a smashed piano made of bronze, is on permanent display in the Martin H. Bush Outdoor Sculpture Collection.

Patricia McDonnell

1. Arman quoted in Alison de Lima Greene, "Arman: An Artist in Our Time," in Greene and Pierre Restany, *Arman, 1955–1991: A Retrospective*, exh. cat. (Houston: Museum of Fine Arts, Houston, 1991), 23.

33 *Wind Directions*

1970
Color pochoir, 30 5/8 x 22 in.
Museum Purchase, 2008.0009

I'm not on the lookout for subject matter, but I am on the lookout for the je ne sais quoi that will become my aesthetic content, and I have to reach consciously and unconsciously into all parts of my life and art experience to make order and choice out of some of that.

Helen Frankenthaler [1]

HELEN FRANKENTHALER FREQUENTLY USES *JE NE SAIS QUOI*, THE FRENCH EXPRESSION MEANING "I KNOW NOT WHAT," to indicate a distinctive yet elusive quality she consistently seeks to achieve in her work. A member of the mid-twentieth-century circle of New York artists known as abstract expressionists, she relies upon subjective impressions, memories, and emotions to create gestural, evocative images. Her signature paintings celebrate the serendipitous results of saturating a surface with rich, liquid colors and allowing them to bleed into blank spaces and layer upon one another. Although trained in easel painting, Frankenthaler was inspired by the drip paintings of her fellow abstract expressionist Jackson Pollock. But instead of dripping paint to produce art, she poured diluted pigments from coffee cans onto unprimed canvases.

Frankenthaler's initial foray into printmaking was tentative, because she was skeptical about how that technically demanding, labor-intensive process would suit her unconventional, immediate approach. Much to her surprise, she found that printmaking, in its various manifestations, offered myriad options for experimentation and allowed her to create artworks that were as lyrical and expressive as her paintings. Since making her first lithograph in 1960, she has published more than two hundred prints and is now recognized as much for these works on paper as for her works on canvas.

Wind Directions is part of the artist's 1970 print series Four Pochoirs. Frankenthaler used large sponges to apply acrylic paint through a stencil (or *pochoir*, in French) directly onto the paper. While the finished prints appear identical, each impression holds the unique color modulations that result from her hand application. While creating *Wind Directions*, she simultaneously laid the groundwork for a subsequent print edition.[2] Each time she applied the colors through the stencil, she carried them beyond the edge of the paper and onto a second sheet beneath it. A year later, she printed on each of those second sheets an etching of thin black lines that radiate out from the blank center to the colored edges. As befits an artist who champions spontaneity and eschews traditional methods, Frankenthaler titled that subsequent print *Free Wheeling*.

Emily Stamey

1. Frankenthaler quoted in "Perceptions of Helen Frankenthaler," in *Helen Frankenthaler Prints, 1961–1979* (New York: Harper and Row in association with the Williams College Artist-in-Residence Program, 1980), 19.

2. For a lengthier technical description of both these prints, see Ruth E. Fine, *Helen Frankenthaler Prints* (Washington, D.C.: National Gallery of Art and New York: Harry N. Abrams, 1993), 19.

ROBERT INDIANA'S *LOVE* "IS ONE OF THE MOST RECOGNIZABLE ICONS OF CONTEMPORARY ART." [1] THE WORK HAS BEEN INDIANA'S BLESSING AND CURSE, launching his fame and fueling criticism but ultimately according him a reputation for insightful artistic commentary.

Born Robert Clark, he changed his surname to that of his native state in 1958, when he was part of the New York art scene. As a teenager working at the *Indianapolis Star*, he had become fascinated by type, and in the former marine warehouse that served as his lower Manhattan studio he experimented with stencils the former occupants had left behind. Indiana created the first *LOVE* in the form of crayon rubbings for Christmas cards in 1964. The following year, the Museum of Modern Art invited him to design holiday cards, selecting a red-green-blue version. And in 1966, the Stable Gallery in New York presented a one-person exhibition of *LOVE* paintings in various color schemes. Unfortunately, the show's poster lacked a copyright symbol – loosing a torrent of rip-offs. While seeking to copyright the image after the fact, Indiana saw cheap imitations, in the form of paperweights, rings, key chains, and other trinkets, suffuse the market. The U.S. Postal Service spread its fame further in 1973 by issuing the authorized *LOVE* stamp, more than three hundred thirty million of which were sold. The ubiquity of tawdry unauthorized versions damaged Indiana's standing, as most assumed he had sold out.

Layers of reference, interpretation, and cultural relevance exist for this complex work. Indiana traces its origins to the Christian Science Sunday services of his youth. Most churches in this denomination, he explained, "have no decoration whatsoever . . . only one thing appears in a Christian Science church, and that's a small, very tasteful inscription . . . God is Love." [2] A member of New York's gay subculture in the late 1950s and 1960s, Indiana conceived *LOVE* to signal covertly this aspect of his identity. [3] Adding to personal memory and context, he also appealed to the tenor of the times, when the country was bitterly divided over the Vietnam War, and the slogan "Make Love, Not War" captured the popular sentiment of a burgeoning youth culture. The first love-in was held in Los Angeles in 1967, and so-called love beads and free love were other signature expressions of the day.

34 *LOVE* (Blue/Green)
Designed 1966; fabricated 1980
Aluminum painted with polymer resin
72 x 72 x 36 in.
Museum Purchase with Student Government
Association funds, 1980.0026

Ever attuned to current social issues, Indiana created The Confederacy series (1965–66) of paintings and prints in support of the civil-rights movement. His advocacy of peace and tolerance has informed much of his art. In recent years, he produced the Peace painting series in response to the September 11, 2001, attacks, and reconfigured the *LOVE* design as a *HOPE* sculpture for Barack Obama's 2008 presidential campaign.

Patricia McDonnell

1. Valerie Vadala Homer, *The Story of LOVE*, exh. cat. (Scottsdale, Ariz.: Scottsdale Museum of Contemporary Art, 2004), 3.

2. Indiana quoted in Susan Ryan, *Robert Indiana: Figures of Speech* (New Haven and London: Yale University Press, 2000), 199.

3. For more on this aspect of his work, see Michael Plante, "Truth, Friendship, and Love: Sexuality and Tradition in Robert Indiana's Hartley Elegies," in Patricia McDonnell, *Dictated by Life: Marsden Hartley's German Paintings and Robert Indiana's Hartley Elegies*, exh. cat. (Minneapolis: Frederick R. Weisman Art Museum, 1995), 56–87.

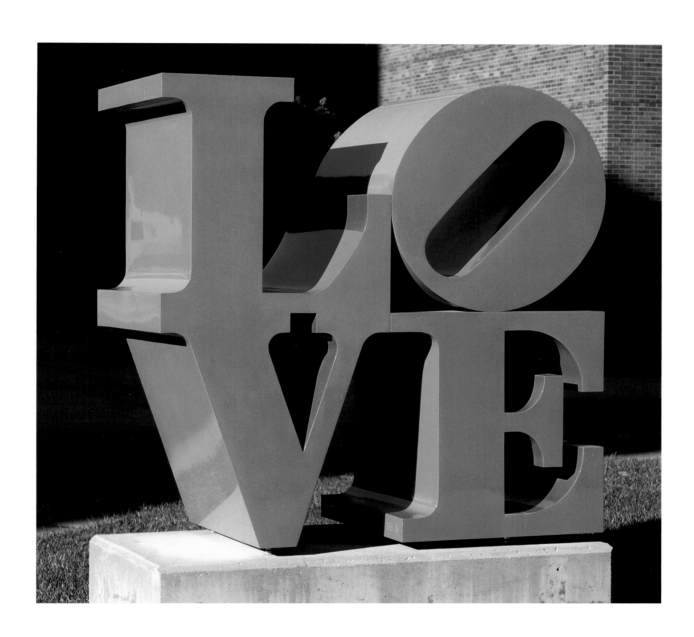

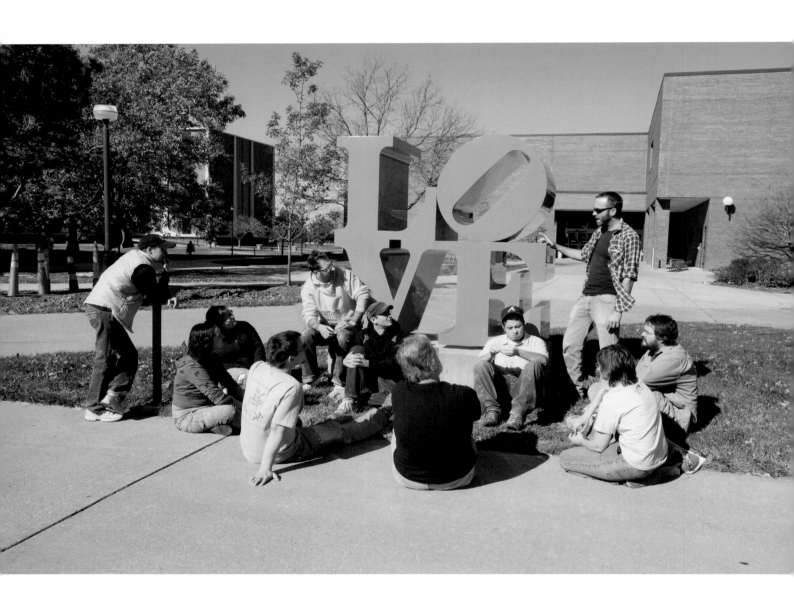

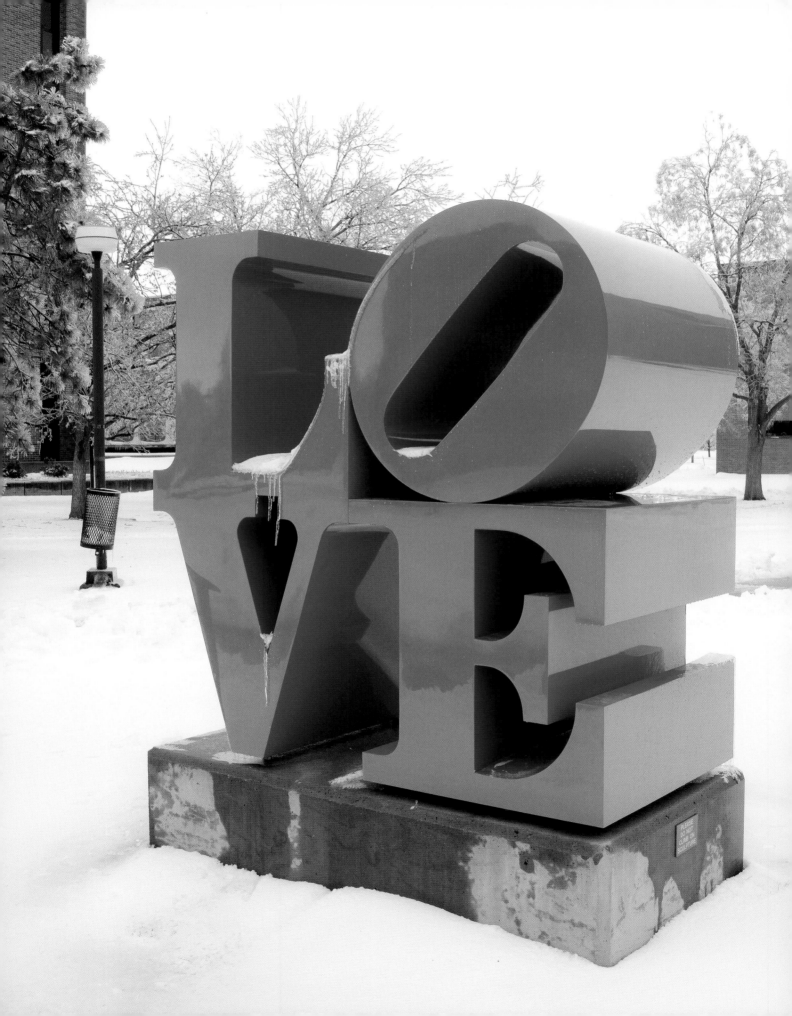

Fernando Botero (Colombian, born 1932), *Man with Cane* and *Woman with Umbrella*, 1977. Bronze, man: 76 ½ x 38 ¼ x 34 in; woman: 89 ¼ x 36 ¼ x 33 ½ in. Gift of George and Virginia Ablah, 1984.0005.001–2.

35 *K123456*
1997
Painted basswood, 14 ¼ x 19 ¼ x 13 ½ in.
Museum Purchase, 1998.0006

THE CREATOR LEFT SPACES FOR THE AIR TO COME
IN Breathing room, as it were. . . . A hive whose
bees have been freed. . . . A once-upon-a-time hub. . . . A
school, elementary. . . . In every cell a separate dream. You
can climb to the top. You can plummet down. . . . The
architect was fired. . . . A jungle gym made by a sadist. . . . A
dollhouse for concrete thinkers.

High-rise. Civic space. Unfinished business. Urban
renewal. Ziggurat. Hamlet. Rubik's (broken brethren) Cube.
Matchsticks. Toy blocks, block logic. Shafts, tunnels, halls,
stacks. Files, drawers, compart, compact. Thoughts, wiles,
secrets, lockets.

Stepping stool? Picture frames? Skeletal remains? Before
or after? Under construction? Being demolished? Ephemera
or artifact?

Antonya Nelson

NO ARTIST REPRESENTS AMERICAN POP ART SO SINGULARLY AS ANDY WARHOL, and no set of works calls this artist to mind so insistently as his Campbell's soup-can images. He incessantly represented this common commercial product: in drawings, paintings, and prints; whole, crushed, and torn; using its traditional color scheme and garish combinations; individually and in multiples. First appropriated in the early 1960s, the Campbell's imagery remained a motif until his death.

Warhol's soup-can debut came in his first solo exhibition, at Los Angeles's Ferus Gallery in 1962: thirty-two painted canvases, each depicting a different flavor, sat on thin ledges like so many cans stocked on a supermarket shelf. A year later, the critic Gene R. Swenson asked Warhol why he had started painting the mundane grocery item. Warhol answered: "Because I used to drink it. I used to have the same lunch every day, for twenty years, I guess, the same thing over and over again." [1]

Such a seemingly simple response captures the themes of familiarity and repetition that are key to understanding pop art generally and Warhol's work specifically. Not guided by any collective agenda or manifesto, pop artists drew imagery from common, abundantly produced sources such as comic books and magazines. Then they created their own artworks by employing many of the same reproduction technologies used to make the source materials. Throughout his career, Warhol took instantly recognizable images – such as Coca-Cola bottles and celebrities' faces – and reproduced them in ways that mimicked and underscored their seemingly infinite circulation in popular visual culture. Using mass-produced images of mass-produced items, he in turn mass-produced his prints and paintings of these commodities.

Warhol's repetition of the soup can was so ubiquitous that artist and image became almost synonymous. This link was aptly caricatured on the cover of the May 1969 issue of *Esquire* magazine, which bore a manipulated photograph of Warhol drowning in a can of Campbell's soup. And in 1977, a depiction of the iconic soup can appeared on the paperback cover of the artist's book of observations, *The Philosophy of Andy Warhol*. The artist had essentially rebranded Campbell's, making its graphic identity a sign not only for the company and its food products but also for his aesthetic approach and for himself.

36 *Chicken 'n Dumplings*
1969
From the series Campbell's Soup II, 1969
Color screenprint on paper, 35 x 23 in.
Museum Purchase with Student Government Association funds, 1971.0014.005

Emily Stamey

1. Warhol quoted in Gene R. Swenson, "What Is Pop Art?: Answers from Eight Painters, Part I," *Art News* 62 (November 1963): 26.

ONE DAY, THERE IT JUST WAS IN THE PARK, where the metal-rooster thing used to be. The rooster had a sign that said, "DO NOT CLIMB ON" and another saying "DO NOT TOUCH." But this one didn't have any sign, and it looked like something you could maybe climb up or slide down, something you could fall into or bounce off of without hurting. The second we were out of the van we were running toward it, arms outstretched, Hannah in front because she's older and fast, but me not far behind, and then Oscar and Liv. Hannah's mom was still in the van, talking on the phone about paying for camp with a credit card, and I already had my hands on the thing's smoothness, my cheek pressed against its whiteness. We couldn't climb it, not even Hannah with her thick-soled shoes and her monkey legs. I couldn't get my arms around it, and it didn't swing or move or do anything. So after not very long, Hannah's mom still on the phone, we four sat on the wood chips in front of it, or maybe behind it, looking up.

"It's an eyeball," Hannah said, picking at the bite on her leg. "No. It's a whole corner of a face. The eye's in the middle, an eyebrow hanging over. See? He's got ears like a pig, and you can only see one. Maybe he's looking at you through a hole in the fence."

"It's a cartoon bubble," Oscar said, still out of breath from running. "Like when someone's talking, the words in it. It fell upside down, got dented."

There was no fight in his voice, and Hannah smiled. We were quiet, just the sounds of cars going by and the sprinkler ch-ch-ch-ing on the other side of the park.

"It's a dollop," I said. I didn't mean to make it funny, but when they laughed, it was funny to me. "Dollop dollop dollop," I said, louder each time, and then Liv said it, too, and I laughed so hard I leaned back, my braid in the grass, and Hannah told me to watch out for chiggers.

"A dollop of whipped cream," I said, sitting up straight, so happy I was almost singing.

"I wish I could get inside it," Oscar said.

Hannah's mom walked toward us, yawning, phone in one hand, keys in the other. She was nice. She let us eat in the van, the stereo playing music. It was kid music, but it didn't bother her. She just drove, like she didn't even hear it.

She looked at the white thing and frowned.

"What the heck is it?" she asked, like she didn't really want to know.

So no one answered.

"That's what I thought." She rolled her eyes, checked her watch. "I should make whatever. Call it art."

Laura Moriarty

37 *Inverted Q, Trial Proof (White)*
Designed 1974; fabricated 1988
Cast resin and white urethane paint
72 x 70 x 63 in.
Museum Purchase, 1996.0001

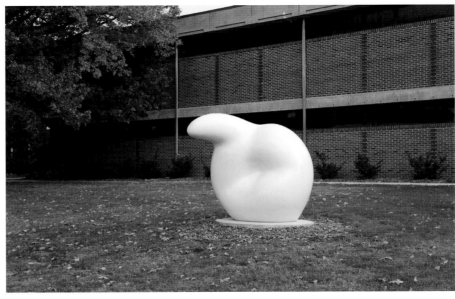

38 *Mourners*
1974
Oil on canvas, 44 ½ x 36 in.
Museum Purchase, 1974.0090.001

MOURNERS IS A VIVID EXAMPLE OF THE POIGNANT HUMANISM EXPRESSED BY THE ARTIST, WRITER, AND ACTIVIST BENNY ANDREWS. One of ten children born to Georgia sharecroppers, he was the first in his family to graduate from high school. Both sides of the family represented mixed ethnicities, but in the segregated South they were alike regarded as African Americans. Andrews would embrace this identity in his art, gaining from and contributing to a strong tradition of storytelling, social protest, and respect for the commonplace – all characteristics shared by black artists such as Romare Bearden, Palmer Hayden, and Jacob Lawrence.

Trained at the School of the Art Institute of Chicago, Andrews moved to New York in 1958. He balanced a studio practice with teaching, attaining full professorship at Queens College of the City University of New York in 1988. Beginning in the late 1960s, he became involved in protesting the under-representation of both African American and women artists in such venerable New York institutions as the Metropolitan Museum of Art and the Whitney Museum of American Art. A cofounder of the Black Emergency Cultural Coalition in 1969, he frequently picketed both museums in order to publicize their apparent indifference to artists of color. In the early 1970s, Andrews developed an art-instruction program for the New York state prison system. These activities coincided with a burgeoning of social-protest movements during that period, which gave him further impetus to air his grievances and advocate for reforms. From 1982 to 1984, Andrews, recognized both as an inspired leader and a skilled artist, directed the National Endowment for the Arts Visual Arts Program.

From the mid-1960s on, Andrews portrayed scenes from and memories of his youth. Often, activities or incidents from his rural Southern background overlapped in a dreamscape of contemporary American life. *Mourners* recalls the religious practice of the Plainview Baptist Church, just outside Madison, Georgia, which he attended with his family. Projecting both pathos and stoic dignity, the artist depicts two women mourners whose expressions of grief and loss are counterbalanced by a cathartic and typically boisterous celebration of life characteristic of black Baptist funerals. According to Andrews, "This poor community of African Americans, oppressed through segregation and lacking many of the necessities for a decent life, could find relief in only one place, the church."[1]

Patricia McDonnell

1. Benny Andrews, "Artist's Statement: The 'Revival Series'," *The Revival Series by Benny Andrews*, exh. brochure (New York: Bill Hodges Gallery, 1995), n.p.

39 *Cover Girl*
1962
Oil on canvas, 11 x 14 in.
Gift of Mr. and Mrs. Arthur Cohen
1977.0041.002

ALTHOUGH SHE PREFERS THE TERM SUPER REALIST, AUDREY FLACK IS BEST KNOWN AS A PHOTOREALIST, an artist whose work stems from one or more photographs and is so detailed and precise that it seems to re-create the source imagery in paint, pencil, or other medium. Flack executed her signature paintings in the 1970s, the decade photorealism became popular in American art, using a projector to enlarge the original photographs on her canvases and an airbrush to apply paint in a manner that mimicked their slick surfaces. The use of mechanical aids was another common practice in photorealism. Flack distinguished herself from her contemporaries by wedding this distinctly twentieth-century technique to imagery inspired by a much older artistic genre. The subject matter of her paintings was inspired by seventeenth-century vanitas paintings – still lifes in which images of flowers, food, skulls, candles, and history books were employed to evoke thoughts of life's temporality. These same objects, as well as photographs, cosmetics, and other personal and contemporary miscellany, appear in Flack's typically large, garishly colored works.

Audrey Flack, *Chanel*, 1974. Acrylic on canvas, 96 x 96 in. Private collection, courtesy of Louis K. Meisel Gallery, New York.

Created with thick, visible strokes of paint in a limited range of colors on a small canvas, *Cover Girl* is stylistically distinct from Flack's hallmark 1970s paintings, but it prefigures them in several ways. Her attention to the shiny caps of Cover Girl foundation-makeup jars and to the gold lipstick tube hint at the precision with which she later depicted light reflections captured in photographs. Here the artist experiments with clustering objects together, the compositional approach characteristic of her later paintings. Especially notable is her choice of objects (the bottles, tubes, and jars of makeup), which links this early painting to many subsequent ones, such as *Chanel* (1974). Cosmetics, used to defy the effects of time, became one of her most frequent vanitas props.

Although Flack limited the kinds of objects she depicted in this early work, she nonetheless might have been alluding to the social and political unrest of the 1960s. In that time, the viewer might interpret a female artist's focus on cosmetics as an early feminist critique of the demands upon women to enhance their appearance. Furthermore, by including both light foundation and coarse washing powder for black hair, Flack was perhaps indirectly acknowledging racial tensions and the civil rights movement. Many of her other 1960s paintings are focused on world leaders and peasant laborers, confirming her interest in political issues and supporting such an associative reading of *Cover Girl*.

Emily Stamey

Audrey Black

SCOTT BURTON WAS ONE OF THOSE RARE ARTISTS WHO CARVE THEIR OWN DISTINCTIVE NICHE. HIS SCULPTURAL FURNITURE STRADDLES CATEGORIES and blurs boundaries in ways that enrich the viewing experience. Reviewing Burton's work, the late art historian Robert Rosenblum acknowledged a "bewilderment in confronting something that belongs comfortably to no familiar category."[1] Burton entered the art world as a critic and historian, became a performance artist, and ultimately emerged as a sculptor and public artist. That unconventional trajectory gave him a broad historical and conceptual perspective as he developed his novel artistic practice.

As a sculptor, Burton focused on furniture design and arranged his objects – often a cluster of chairs and tables – like tableaux or stage sets awaiting actors. Viewers observe and make use of the seating and tables to "complete" the work, whether it is displayed in a gallery or outdoors as public art. Inspired by modern design theories, Burton invited engagement with his sculptures as a means of heightening individuals' awareness of the built environment and, as a result, their aesthetic sensibility.

Located in the Martin H. Bush Outdoor Sculpture Collection at Wichita State University, *Münster Benches, a Pair* is one of two editioned Burton sculptures originally commissioned by the city of Münster, in the former West Germany. In 1977, 1987, 1997, and most recently 2007, this Westphalia municipality engaged prominent international artists to create public art. While researching his project, Burton looked to the neighboring town of Hagen and its Villa Hohenhof, a 1908 house (now museum) designed by Henry van de Velde, the highly influential Belgian architect, interior designer, theorist, and teacher who was an early proponent of the fully designed environment, or *Gesamtkunstwerk*. In 1906 he established and became the first director of the School of Arts and Crafts in Weimar, Germany, which was succeeded after World War I by the legendary Bauhaus. Van de Velde developed the building, interiors, furnishings, and garden of the Villa Hohenhof, creating a vibrant embodiment of the encompassing-design ethos.

40 *Münster Benches, a Pair*
Designed 1987; fabricated 1999
Painted aluminum, 40 × 190 × 58 in. each
Museum Purchase, 2000.0001.a–b

Knowledgeable about design history and sympathetic to the efforts of van de Velde and the Bauhaus modernists to awaken the public to a richer array of aesthetic pleasures, Burton based his commissioned benches on those in the Villa Hohenhof garden. Yet, as in all his other works inspired by design precedents, he altered the original, subtracting the undulating lines and flourish of art nouveau that van de Velde had employed. The result is a spare, reductive example of late-twentieth-century public art – one that invites those in the campus community to sit, pause from the academic bustle, and find a moment's aesthetic pleasure.

Patricia McDonnell

1. Robert Rosenblum, "Scott Burton: The Last Tableau," *On Modern American Art: Selected Essays by Robert Rosenblum* (New York: Harry N. Abrams, 1999), 305.

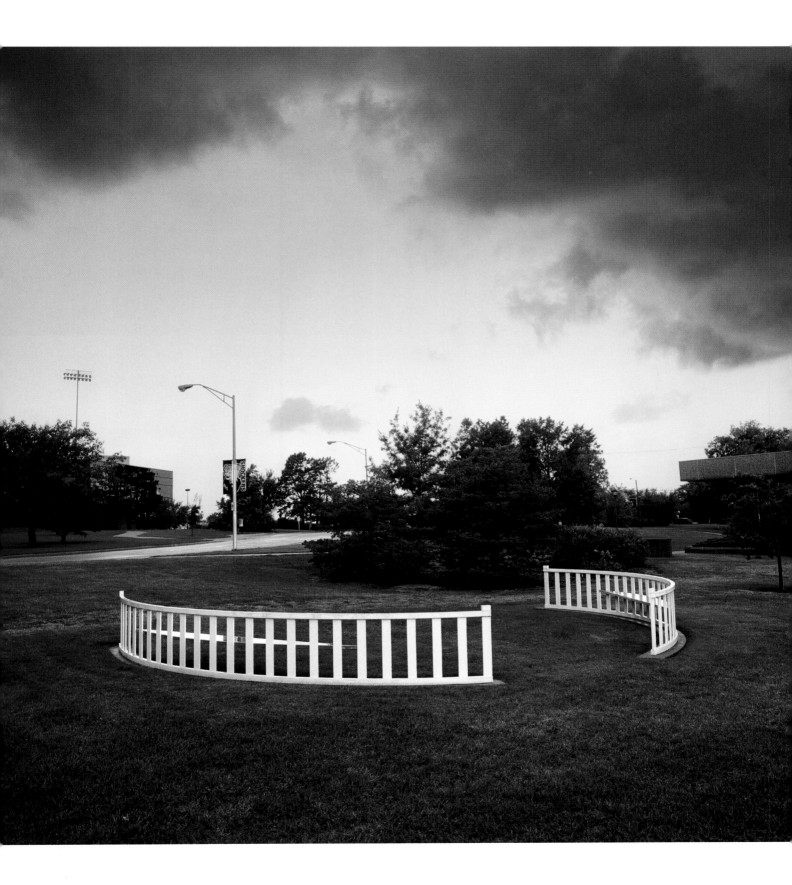

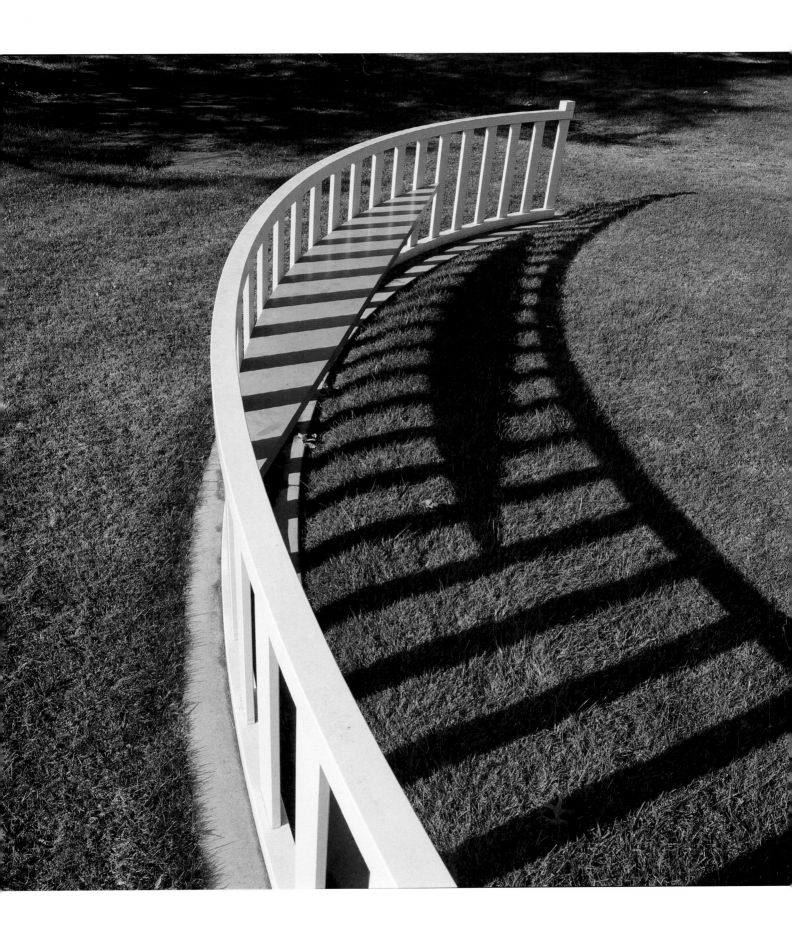

THE MINIMALIST SCULPTOR RICHARD SERRA FIRST DREW CRITICAL ATTENTION IN 1968 WITH THE EXHIBITION OF *SPLASHING,* a work he made by flinging molten lead against the wall and floor of the Leo Castelli Warehouse in New York. Beyond the cumulative, three-dimensional form it ultimately took, this piece was about the process of moving lead through space. A year later, he created *One Ton Prop,* a sculpture composed of four rectangular lead plates – weighing a total of one ton – propped against one another to create a sort of open cube. Although static, the work suggests potential danger: What if one of the heavy pieces were to shift out of balance and make the work collapse?

Such physical intensity and attention to space remain hallmarks of Serra's work. Over the past four decades, he has reaped international acclaim for producing monumental sculptures, most of them wrought from rolls and sheets of Cor-Ten steel, that have a strong impact on the interior and exterior spaces they occupy. Seeing and comprehending these sculptures in their entirety requires viewers to move around them. Employing twists and curves both subtle and extreme, they convey an implied motion and, in turn, activate their surroundings.

Serra has also long been a printmaker, working out on paper many of the same concepts involving mass and space that he explores in his three-dimensional pieces. In 2004 he created a print series, Arc of the Curve, in which a nearly rectangular but ever so slightly curved black form occupies each sheet of paper. Tightly fit, these forms seem to strain against the confines of their white backgrounds. Every one of the prints bears a darkly confrontational mood. Printed on two seven-and-a-half-foot-tall sheets of paper that together measure eight feet across, *Double Transversal* is perhaps the most foreboding of them all.

41 *Double Transversal*
2004
Etching on paper, two sheets: 90 x 48 in. each
Museum Purchase, 2006.0013

To create this series, Serra worked with Gemini G.E.L. (Graphic Editions Limited) in Los Angeles, a nationally esteemed print workshop and publisher whose staff has frequently collaborated with the artist. In 2003 he asked Gemini G.E.L. to obtain the oversized copper plates that would be used in Arc of the Curve, explaining that he wanted to attempt "prints larger and fuller than any previous effort." [1] The prints' rich texture is the result of rubbings taken of an exterior stucco wall. A customized vertical tank-and-pulley system was built to accommodate the acid bath for the enormous plates that printed the texture. Each plate was etched in acid for four to five days and then coated with more than a pound of ink before its impression was made on paper.

Like Serra's steel sculptures, *Double Transversal* has an undeniable presence that impels viewers to move backward in order to take in its scale and forward to comprehend its sensuous surface.

Emily Stamey

1. James Reid, "Arc of the Curve (2004) Workshop Notes," courtesy of Gemini G.E.L., Los Angeles.

42 *Sodbuster: San Isidro*
Designed 1981; fabricated 1983–84
Colored fiberglass with acrylic-urethane
finish, 71 x 62 x 243 in.
Museum Purchase with Student Government
Association funds, 1987.0002

Luis Alfonso Jimenez, *Honky Tonk*, 1981. Lithograph and
glitter on paper, 35 x 50 in. Museum Purchase with Student
Government Association funds. 1978.0009.

THE GRANDSON OF MEXICAN IMMIGRANTS AND
A NATIVE TEXAN who spent much of his life in New
Mexico, Luis Alfonso Jimenez celebrated the vitality of
the Southwest and its people. In prints and sculptures,
he depicted them as figures at once muscular, sensuous,
and dynamic. Although rooted in everyday experiences,
Jimenez's subjects and their arrangements are informed by
art-historical precedents: the compositions of Renaissance
devotional art, the American regionalist Thomas Hart
Benton's sinewy and rhythmic figures of the 1930s, the
monumental scale and moral urgency of Mexican muralists
such as Diego Rivera in that same decade, the embrace of
everyday objects and materials characteristic of 1960s pop
art, and the stylization of traditional Southwestern folk art.

Jimenez created broadly accessible vernacular art. He accomplished this not only through his readily recognizable subjects
– honky-tonk bars, cowboys, lowriders – and bold style but also through his choice of materials. He cast a number of his
public sculptures in industrial fiberglass and coated them in acrylic-urethane finishes, like those used on hot-rod cars, to
achieve shiny surfaces that bore a familiar tactile appeal.

Sodbuster: San Isidro embodies these signature features. Massive in scale, bold in color and form, and with a smooth, highly
polished surface, this sculpture depicts a farmer leading a team of oxen. Describing his stylistic approach here, Jimenez said:

> [I]t's very much the way the folk art sculptures are done in New Mexico. The sweat
> beads are very much like the blood beads on the Christ figures here in New Mexico,
> and in Mexico, the same sort of emphasis on the man's arms, the muscles, the same
> kind of exaggeration and distortion; obviously a lot of stylization but consistent with
> what happens with folk art.[1]

Jimenez underscored these associations by subtitling the sculpture *San Isidro*, the Catholic patron saint of farmers.
Although aesthetically rooted in Southwestern religious folk art, the sculpture also honors the agrarian traditions of the
Great Plains, where *sodbuster* was once a slang term for farmer. In fact, Jimenez first created *Sodbuster: San Isidro* in 1981 as a
commission for the city of Fargo, North Dakota. Two years later, when the Ulrich Museum approached him about purchas-
ing a work for its outdoor collection, Jimenez suggested that the museum consider his second casting of *Sodbuster*. Once the
sculpture was acquired and installed, Wichita State University landscapers planted native Kansas prairie grasses at its base,
underscoring an association with this region, its early prairie homesteaders, and the endurance of its farming communities.

Emily Stamey

1. Jimenez quoted in *Man on Fire: Luis Jimenez*, exh. cat. (Albuquerque, N.M.: Albuquerque Museum, 1994), 139.

Born to a Polish mother and a Ukrainian father, Ursula von Rydingsvard spent her childhood displaced, moving with her family among Germany's post–World War II labor and refugee camps. Not surprisingly, her sculptures seem to resound with echoes of these formative years. "I was exposed to very few objects," the artist recalled,

and the ones I grew very attached to were the things that belonged to my father, his agricultural tools; and the things which belonged to my mother, her domestic implements, like bowls, washboards and spoons, and so on. . . . I still feel that these very primitive implements, without a machine attached to them, that you work food with, that you work the soil with, they're the real icons in my eyes, in my head.

The manual labor von Rydingsvard associates with these objects and with her family also informs the making of her sculptures. Although she uses electrical tools, her works require a physically demanding process. She repetitively cuts and scores beams of cedar as she stacks, clamps, and laminates them together, finally darkening their surfaces by rubbing them with powdered graphite.

These complex sculptures invite multiple, sometimes contradictory, readings. Their rough, abraded surfaces evoke natural landscapes and manmade ruins. Their substantial masses feel at once threatening and protective. *Bowl with Lips* bears these characteristic traits and also employs von Rydingsvard's signature vessel form, a motif she turns to often because of its rich associative potential. Bowls are a fixture in her own thoughts, but their archetypal form also recalls how bowls have been universally used for both domestic and sacred purposes, as holders of nourishment for both body and soul. For von Rydingsvard, the bowl is "a world, a vessel of emotions."[2] She also frequently thinks about the bowl's kinship to the human body – a link underscored by the present work, whose title and round opening suggest lips parted in speech. Habitually reticent to assign a single interpretation to any of her sculptures, the artist undoubtedly would hope that this one speaks differently to each viewer.

43 *Bowl with Lips*
2000
Cedar and graphite, 77 x 56 x 70 in.
Museum Purchase, 2003.0015

Emily Stamey

1. Von Rydingsvard interviewed by Deborah Emont Scott in Michael Brenson, Ursula von Rydingsvard, and Deborah Emont Scott, *Ursula von Rydingsvard*, exh. cat. (Kansas City, Mo.: Nelson-Atkins Museum of Art, 1997), 27.

2. Von Rydingsvard quoted in Martin Friedman, "Ursula von Rydingsvard: Mining the Unconscious," in Ursula Von Rydingsvard, Stephen Fleishman, and Martin Friedman, *Ursula von Rydingsvard: Sculpture*, exh. cat. (Madison, Wisc.: Madison Art Center, 1998), 22.

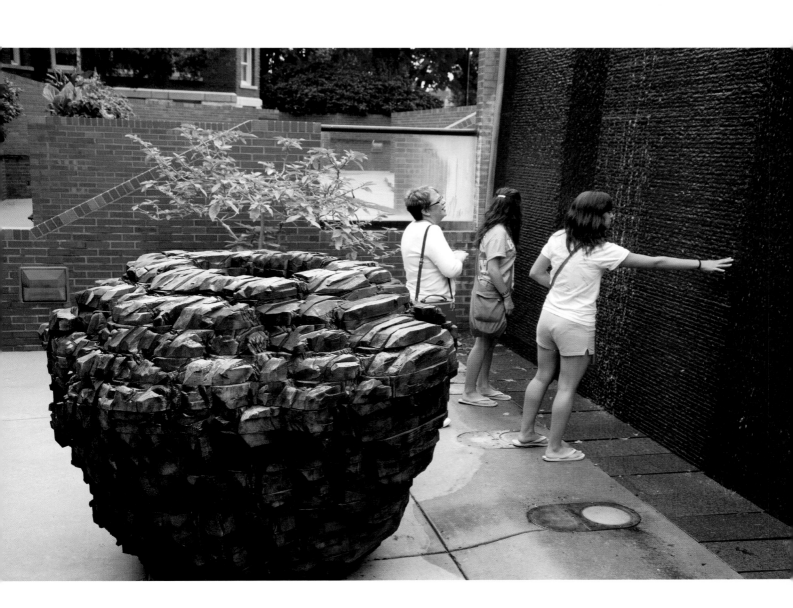

WHEN DAVID REED MOVED INTO HIS FIRST NEW YORK STUDIO IN 1971, HE AND OTHER ARTISTS OF HIS GENERATION FACED A CHALLENGE: how to keep the medium of painting vital when images were traveling more rapidly than ever before and many modern art movements seemed exhausted. Convinced of paint's infinite potential and determined to "make the paintings they say can't be made," he set about creating a singular form of abstraction.[1] His energetic, color-saturated works draw upon a range of sources, including art history, landscape, and film.

At first glance, the free-form arabesques of color and decentralized composition of *#471* resemble 1950s abstract expressionist paintings by Franz Kline and Jackson Pollock. But Reed's flat surface, combining straightedge and curvilinear elements and showing little trace of brushwork, suggests this canvas is the product of painstaking labor and deliberation – in contrast to the spontaneous approach taken by those two painters. The undulating ribbons of hot red on the left and pale pink on the right, made by applying paint with a spatula to produce varying degrees of translucency, assume a three-dimensional, photographic quality. Resembling high-contrast enlargements of drapery folds in Baroque portraits – a subject that fascinates Reed – they add illusionistic depth, suggesting that he thinks of abstraction in symbolic and experiential terms.

Reed, an avid moviegoer, readily admits that film has changed the way he sees both art and the world.[2] Many of his horizontal images bring to mind the sweeping panoramas of Technicolor westerns, and he talks about the vibrant palette of the vertical *#471* in cinematic terms:

I was trying for every possible extreme of color – light and dark, warm and cold, the extremes of hue in the red and green. I also had some idea that if I could glaze the same hue over a paler version of that hue, I could end up with a "super color," a kind of neon-glare-y quality that makes me think of Superman.[3]

44 *#471*
1999–2000
Oil and alkyd resin on canvas
110 1/4 × 34 1/8 in.
Museum Purchase, 2002.0014

Reed recalls hearing the art dealer Nicholas Wilder observe that the painter John McLaughlin's geometric abstractions always ended up in bedrooms because their owners wanted them to be the last things they saw at night and the first things they saw in the morning. At that moment, Reed says, he realized he wanted to be a "bedroom painter," an artist whose work people live with intimately. Ideally, his paintings would be "part of normal life, seen in private moments of reverie."[4] To that end, he has made works, such as *#471*, that serve up equal measures of painterly smarts and sumptuous delight, mirroring the complexities and pleasures of everyday life.

Toby Kamps

1. Reed, telephone conversation with the author, October 20, 2009.

2. David Reed, "Journal," in *New Paintings for the Mirror Room and Archive in a Studio off the Courtyard*, exh. cat. (Graz, Austria: Neue Galerie Am Landesmuseum Joanneum, 1996), 13.

3. Reed, e-mail to the author, October 21, 2009.

4. Arthur C. Danto, "Between the Bed and the Brushstroke: Reading the Paintings of David Reed," *David Reed*, exh. cat. (Cologne: Kölnischer Kunstverein, 1995), 71.

WHETHER LOCATED IN PARKS OR SUBWAY STATIONS, IN FRONT OF COURTHOUSES OR LIBRARIES, ON STREETS OR PLAZAS, TOM OTTERNESS'S PUBLIC SCULPTURES HAVE A COMMON AESTHETIC. Contrasting extremes of scale, substituting animals for people, and referencing myths and fairy tales, he imbues his works with an endearing playfulness that engages viewers' attention.

Wichita State University's *Millipede* originated as a smaller sculpture in an installation Otterness created in 2004 for Puerto Rico's Camuy River Cave Park. Since then, he has produced multiple millipedes, each version possessing different attributes. The one at the Phoenix Convention Center in Arizona, for instance, is part of an installation, titled *Social Invertebrates* (2008), which also includes a bronze walking stick, a scorpion, tiny rounded humanlike figures, and a scattering of coins. The Wichita *Millipede* stands on a concrete apron across from the Ulrich Museum's front entrance, bracketed by a key-shaped flower bed whose springtime tulips are a well-loved campus amenity. Although it is not installed among other Otterness creatures, it keeps deliberate company with its surroundings. As the artist explained in his proposal, the work is meant to connect metaphorically to the university as a whole and specifically to the other sculptures near it.

A millipede's body is composed of linked segments working together and heading in one direction. . . . The content relates to the playful surreal birds and insects within [Joan Miró's mural] Personnages Oiseaux. The Millipede within the tulip beds presents a symbiotic relationship – millipedes eat tulips in fact. The sectioned construction of the Millipede also relates to Andy Goldsworthy's Wichita Arch.[1]

45 *Millipede*
2008
Bronze, 60 x 48 x 300 in.
Museum Commission with funds from Marcia and Ted D. Ayres, The Bastian Foundation, Joan S. Beren Foundation, Ralph and Alta Brock, Carter Community and Memorial Trust, n.a., UMB Bank, Corporate Trustee; Emprise Bank, J. Eric Engstrom, Fidelity Bank Charities, Dr. Sam and Jacque Kouri, Jane C. McHugh, Dee and Mike Michaelis, Paul Ross Charitable Foundation, Dan Ray Rouser, Wilson Foundation, and the Student Government Association, 2008.0005

Otterness's knack for provocatively matching content to context is evident, for example, in the *Millipede*'s marching feet, which call to mind the notion of collective work. Note that half of them sport women's heels while the other half wear men's loafers, a configuration that would require coordination and cooperation in order to complete a task. A much-bigger-than-life insect boasting shoes pairs nicely with the morphed human (*personnages*) and bird (*oiseaux*) figures in the Miró mural (cat. no. 16). Furthermore, as Otterness's proposal suggests, the *Millipede* relates organically to both the flower bed surrounding it and to Goldsworthy's nearby *Wichita Arch*, in which a growing tree marks the passage of time (cat. no. 49).

Here, as with all Otterness sculptures, interpretive possibilities abound. Children can incorporate *Millipede* into a world of make-believe. Someone who has read *Alice's Adventures in Wonderland* might link this bronze creature with the quizzical, hookah-smoking caterpillar in Lewis Carroll's book. A geologist looking at it would know that millipede fossils are among the oldest ever found. This potential to spark thoughts and conversations is what makes the *Millipede* an apt addition to a university campus, where meaningful exchanges of ideas foster discovery and learning.

Emily Stamey

1. Otterness to David Butler, Director, and Katie Geha, Curator, Edwin A. Ulrich Museum of Art, n.d., Ulrich Museum of Art object file.

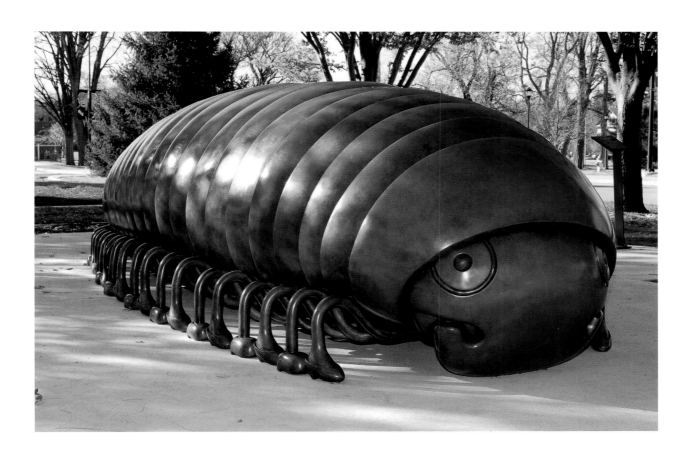

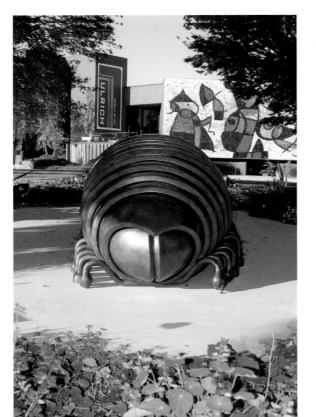

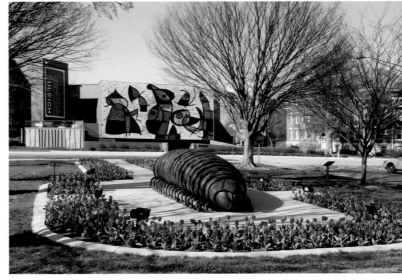

46 *Picnic on the Esplanade, Boston*
1973 (printed 2006)
Cibachrome print on paper, 27 ¹/₂ x 40 in.
Museum Purchase, 2006.0009

NAN GOLDIN, WHO DESCRIBES HER PHOTOGRAPHY AS A VISUAL DIARY, established her reputation with *The Ballad of Sexual Dependency* (1979–86), an oft-reworked serial portrait of the artist and those nearest and dearest to her. In this pulsating record of intimacy and estrangement, good times and bad, no image is more powerful than one of the photographer herself, revealing evidence of physical abuse inflicted by her boyfriend. Another disturbing photograph captures Goldin's wary face in a tableau that includes her batterer, who sits calmly smoking on the edge of a bed.

Ballad was first formulated as a slide show comprising hundreds of snapshotlike images, accompanied by a musical soundtrack whose compass ranged from the Velvet Underground to Maria Callas. The work appeared in an eight-hundred-image, forty-five-minute-long prerecorded version at the Whitney Biennial in 1985 and, a year later, was published in book form.[1]

Goldin was familiar with Larry Clark's images of a drug underground in his book *Tulsa* (1971) and with Diane Arbus's photographs of nudists, freak-show performers, and other individuals rendered grotesque when Arbus recorded them. But *Ballad* revealed the downtown New York scene in its raw ascendancy and caught the attention of the art world not only for its shock value but also for its artistry.

Picnic on the Esplanade, Boston, which is included in the published version of *The Ballad*, is an early, rather atypical Goldin image. It recalls a famous Henri Cartier-Bresson photograph from 1938 of a family picnic by the Marne River. There is an Arbus-like twist, however. Far from being what it might appear at first glance – a sweet birthday gathering of some girlfriends – a second look raises a not-so-simple question: Just how many of those enjoying the cake are female? Here, Goldin's snapshot style, every bit as artful as the Frenchman's, differs considerably from the more formal approach of Arbus. Moreover, whereas Arbus was an outsider, Goldin, as she herself has written, is a member of the group.[2] Although her camera bag and cigarettes are the only evidence of her presence, she is clearly within a circle of friends.

Goldin made the picture in Boston several years before her move to New York in 1978. Her post-*Ballad* photographs are in part a record of loss, including the ravages of AIDS, drugs, and other misfortunes: two people shown here did not survive. In the book version of *The Ballad*, *Picnic on the Esplanade* appears toward the end, as a reminder of the happiness Goldin found with that spirited group. "I used to think I'd never lose anyone as long as I photographed them enough," she has said.[3] But in the context of *The Ballad*, this image indicates a different, if equally melancholy idea, the one suggested by Marcel Proust's observation that "the only true paradise is a paradise that we have lost."[4]

Robert Silberman

1. Nan Goldin, *The Ballad of Sexual Dependency* (New York: Aperture, 1986).

2. She noted, "I'm not crashing; this is my party." Ibid., 6.

3. Goldin quoted (from a 1995 BBC documentary) in Éric Mézil, "A Woman Under the Influence," in Paulette Gagnon, *Nan Goldin*, exh. cat. (Montreal: Musée d'art contemporain de Montréal, 2003), 59.

4. Marcel Proust, *In Search of Lost Time*, vol. 6, *Finding Time Again*, trans. Ian Patterson (London: Penguin, 2003), 179.

THE WRITHING, CONTORTED FIGURES IN ROBERT LONGO'S SERIES OF CHARCOAL-AND-GRAPHITE DRAWINGS MEN IN THE CITIES HAVE BECOME ICONIC. Caught mid-fall, head back, arms and legs flailing, the man depicted in *Untitled* captures the Zeitgeist of a jittery period whose unofficial motto might have been, "If you're not living on the edge, you're taking up too much space." Longo's images of men and women embody the convulsive energy and poses of punk rock as well as the social strife of the Reagan years. Like Cindy Sherman's self-portrait photographs representing scenes in imaginary B-movies and Jenny Holzer's distillations of vast philosophies into pithy one-liners broadcast on posters and LED signs, they are emblems of early 1980s art.

According to Longo, the idea for Men in the Cities came from a clay relief figure he made based on a publicity photograph of a murder scene in the German film director Rainer Werner Fassbinder's *An American Soldier* (1970). Longo was impressed by the way a character in the film, dressed in a hat and tie, is shot in the back and leaps forward, chest arching violently – forming a terrifying yet elegant airborne arabesque. The director Sam Peckinpah and actor-director Clint Eastwood were popularizing graphic, melodramatic death scenes in their movies, and Longo wanted to capture that stylization in his drawings, along with the "hot and fast" new movements developed by singers in bands such as The Contortions and Talking Heads.[1] He invited friends, including Cindy Sherman and his then-girlfriend, artist Gretchen Bender, to model for him on the roof of his New York apartment building, snapping pictures as he threw tennis balls at them to provoke spontaneous, full-body dynamism. Longo and his assistants transformed the figures through aggressively scraped and worked drawing into stark, high-contrast, nearly life-size images.

The critic Carter Ratcliff referred to the figures in Men in the Cities as "failed caryatids," collapsing members of an empty contemporary culture that grants them no legitimate burdens.[2] But Longo himself took a more positive attitude: "[M]y art aspires to freedom and truth and hope," he said. "It tries to mediate between power and peace."[3] The ancestors of Men in the Cities, Longo recently asserted, include Greek and Roman sculptures and the paintings of Caravaggio, Edward Hopper, and Egon Schiele.[4] Like the heroes and antiheroes in those works, the figures in Men in the Cities embody the spirit and struggles of their time.

47 *Untitled*
1980
From the series Men in the Cities, 1979–82
Charcoal and graphite on paper, 60 × 40 in.
Museum Purchase, 2002.0027

Toby Kamps

1. Richard Price, "Save the Last Dance for Me," in Price, *Men in the Cities, 1979–1982*, exh. cat. (New York: Harry N. Abrams, 1986), 88.

2. Carter Ratcliff, "Robert Longo: The City of Sheer Image," *Print Collector's Newsletter* 14 (July–August 1983), 98.

3. Longo quoted in Howard N. Fox, "In Civil War," in Fox, *Robert Longo*, exh. cat. (New York: Rizzoli and Los Angeles: Los Angeles County Museum of Art, 1989), 48.

4. Richard Price, "Interview with Robert Longo," in Price and Cindy Sherman, *Robert Longo: Men in the Cities – Photographs, 1976–1982* (Munich: Schirmer/Mosel, 2009), 11.

48 *Torn Leaf Line Held to Fallen Elm with*
Water, November 15, 2002
2002
Cibachrome print on paper, 20 x 59 ½ in.
Museum Purchase, 2003.0014

IN THE WIDE KINGDOM IS A HIDDEN CLEARING
WHERE THE WATER RUSHES THROUGH, where all
through the night tiny hands gather only the proper foliage
– fragile, amber, identical – put together tenderly, puzzle-
perfect, in the deep dark where faith always must reside.

It's a difficult palette, the arm of a tree, slim bridge flexed
over the risky river. All every night they toil, little laborers
of love and supplication, unsung, unseen, servants to the
coming eye, the luminous Sun.

Gold leaf: literal!

And yet by nightfall, after every gleaming dawn and day, as
every night settles once again, despite every effort, through
its golden, gleaming lovely center develops the wending
disturbance, the savage jagged crack, criminal and unavoid-
able, grinning heresy to split and spoil – to remind the
toilers their work is never done.

Antonya Nelson

49 *Wichita Arch*
2004
Kansas limestone and Australian elm
140 x 270 x 50 in.
Museum Commission, 2004.0014

CAREFULLY CRAFTED OF NATURAL MATERIALS that are often gathered impromptu on site, the sculptures of Andy Goldsworthy are meditations on place and time. Simultaneously a part of the surrounding landscape and distinct from it, each work bears an inherent, subtle tension – between being in and out of place. As well, each sculpture maintains a tenuous relationship to time. Constructed of such materials as leaves, icicles, sand, and flower petals, they are destined to change or inevitably vanish. Even those works made of more durable substances slowly transform as they weather with the passing seasons.

Goldsworthy frequently constructs stone arches – in different locations, with different materials, and at different times. Describing the arch's intrinsic appeal, he writes: "I experience the vigour and force of stone in the arches that I make, one side clasping the other . . . so that neither gives way."[1] He likes quoting the British author D. H. Lawrence's description of the arches in Lincoln Cathedral: "Here the stone leapt up from the plain earth, leapt up in a manifold, clustered desire each time, up, away from the horizontal earth."[2] Clearly, for Goldsworthy the arch is a dynamic form, rich with metaphorical possibilities.

For *Wichita Arch*, the artist specified Kansas limestone and explained his interest in using this material in this particular place:

> I love the idea of an arch of [lime]stone here because the stone is so hidden, there
> is no sense of it being here. But not only is it there, it used to be the sea. . . . So we
> are the furthest away from the sea you can possibly get in America, and there's the
> presence of the sea.[3]

Although it is not native to Kansas, the elm tree Goldsworthy planted beneath the arch has connections to place as well: at the site in Cottonwood Falls, Kansas, where limestone for the arch was quarried, a lone elm captured his attention. Coincidentally, elms were the first trees planted on the university campus, in 1896.[4] When first installed, the arch seemed to shield the young plant. But over time, the elm's branches are spreading out, up, and around the arch, so the two elements of the sculpture become entwined. Like all of Goldsworthy's works, they celebrate the elemental beauty of the natural world and the inexorable passage of time.

Emily Stamey

1. Andy Goldsworthy, *Stone* (New York: Harry N. Abrams, 1994), 95.

2. Ibid., quoting Lawrence's novel *The Rainbow* (1915).

3. Goldsworthy quoted in Chris Shull, "World-Renowned Sculptor at WSU," *Wichita Eagle*, October 29, 2004.

4. George M. Platt, Hugo Wall School of Urban and Public Affairs, to Ulrich Museum of Art staff, "Goldsworthy Sculpture Site," Wichita State University interoffice memo, October 1, 2004, Ulrich Museum of Art object file.

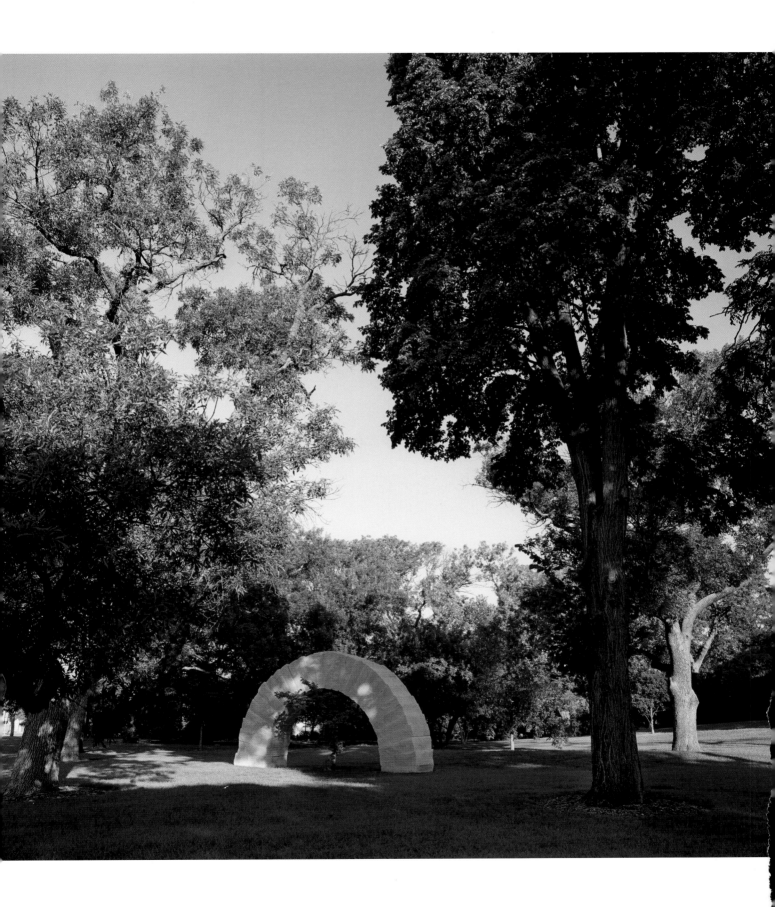

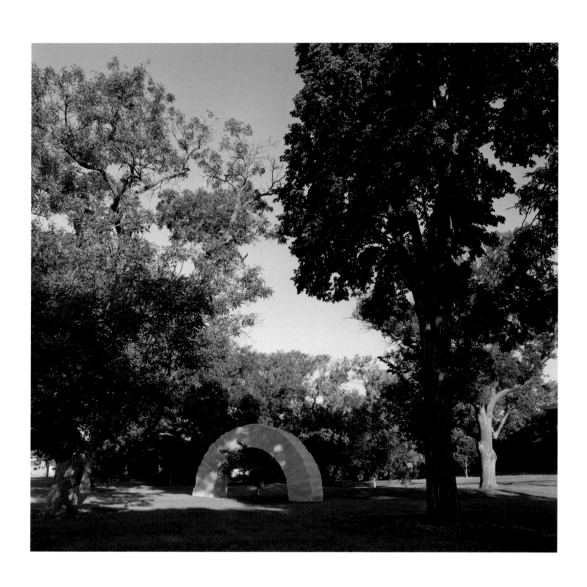

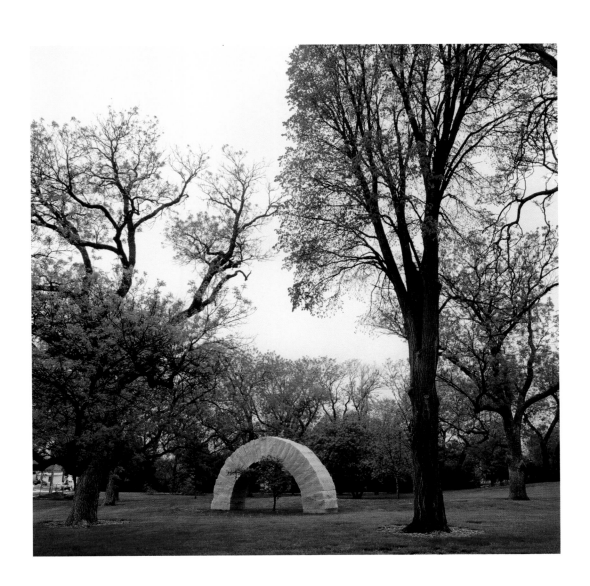

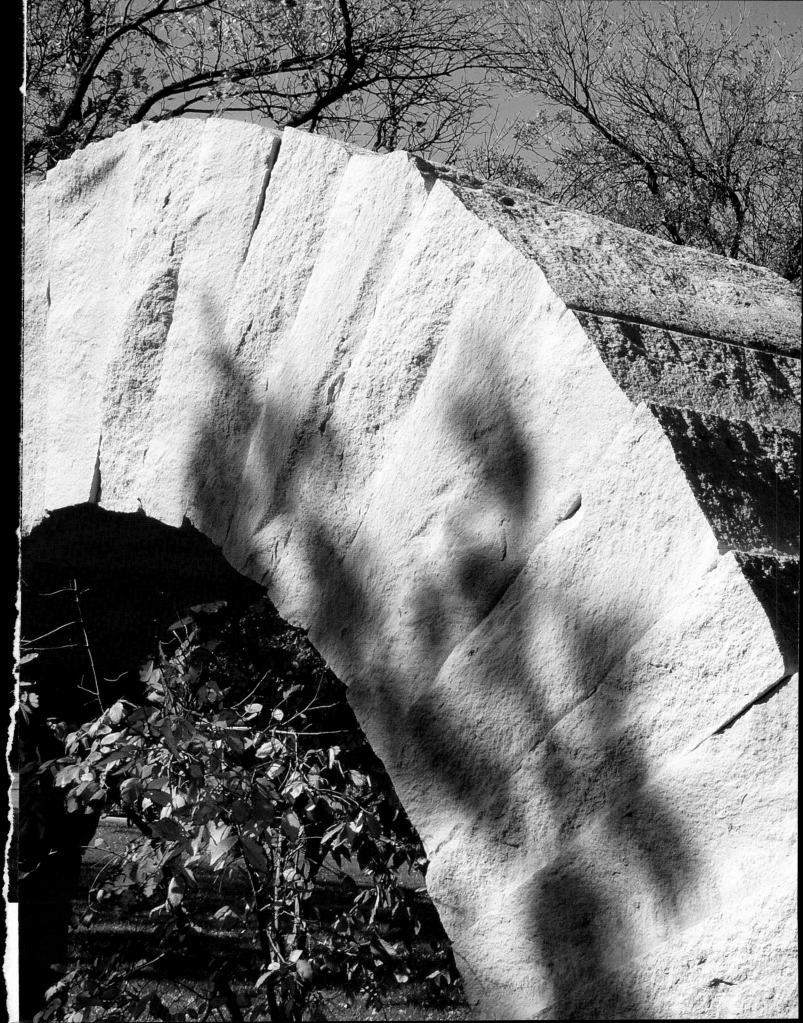

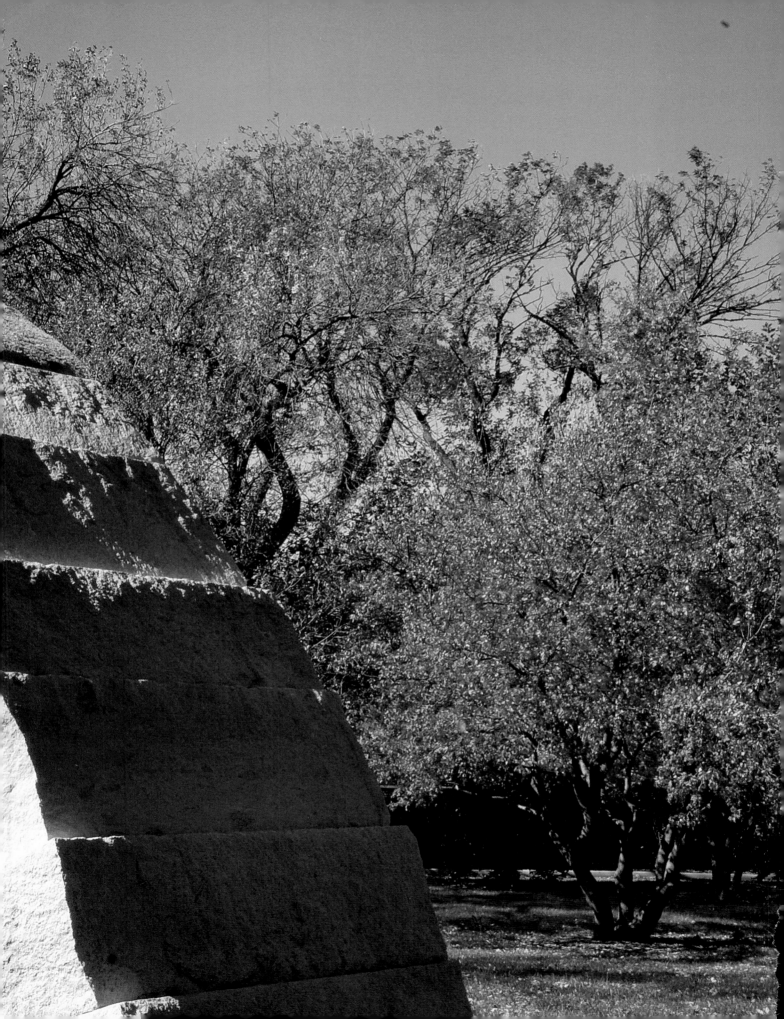

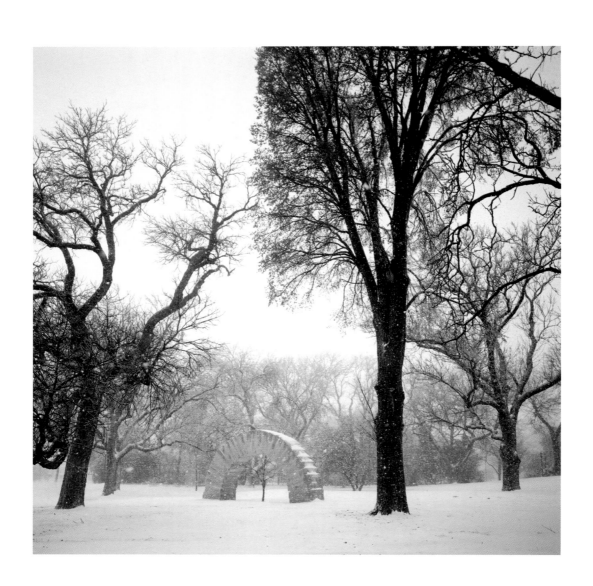

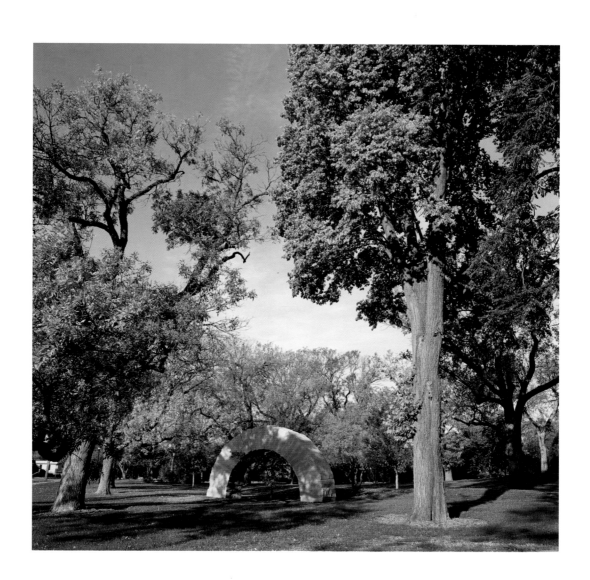

Upon entering the darkened gallery, visitors see a glowing box on the floor in the middle of the room. A circular opening punctuates its opaque top, and its transparent sides are covered on the inside with a dark, sootlike dust that is mysteriously smeared and wiped away. Two nude human figures, male and female, slowly twist and turn within the box, as if attempting to find a comfortable position in their tight enclosure. Occasionally, one of them extends a hand through the opening, leaving dark smudges on the top of the box. From elsewhere in the gallery, a female voice whispers a list of male and female first names. As the couple continues twisting and turning, their naked bodies become coated in the dust that once obscured them from view; the sides of the box become transparent as the figures darken. Then the box goes blank. Moments later, it is illuminated again, and the surreal, dreamlike sequence repeats itself.

Peter Sarkisian first exhibited *Dusted* at New York's I-20 Gallery in 1998, gaining wide recognition for this singular video sculpture. Trained in cinematography, he had begun making video installations four years earlier. Critics applauded his bold move to replace the video screen with a three-dimensional object that occupied space in the gallery and demanded viewer engagement. As he said at the time:

There is a real sense of shared space with the image. You don't get that when you watch television because you're looking at a box held to a frame. Television is a reference to another time and place. With my stuff there's less a sense of mediation between you and the image.[1]

50 Dusted
1998
Five-projection digital video, plywood box, and audio track, 29 ½ x 33 x 33 in.
Museum Purchase, 2003.0001

Although *Dusted* reaped nearly unanimous praise, critics made divergent associations with it. They ranged from viewing the couple as Adam and Eve, to musing on the difficulties of modern-day romantic relationships, to comparing the traditions of abstraction and figuration in art history. Sarkisian himself saw *Dusted* in even broader and more philosophical terms: "The core of this work is balance," he said, "the equal and opposite relationship between clarity and obscurity, growth and decay, life and death."[2]

Interestingly, neither the artist nor those writing about this work dwelt on his use of technology here. Although his medium is video, Sarkisian does not draw attention to it. Instead, he employs it imaginatively to create illusionistic scenes that invite careful attention and encourage contemplation.

Emily Stamey

1. Sarkisian interviewed by Margie Romero, *Ticket*, January 14, 1999: 16.

2. Sarkisian quoted in Valerie Loupe Olsen, *Peter Sarkisian: Dusted*, exh. cat. (Houston: Glassell School of Art of the Museum of Fine Arts, Houston, 2002), 9.

To make *Family Tree*, a set of nine self-portrait photographs, the Chinese-born, now international artist Zhang Huan invited three traditional calligraphers to spend a day painting kanji characters on his face. Asked to maintain a solemn attitude and to keep working even after their words had become a black mask, the calligraphers gradually obscured his features with ink. The writing included proverbial stories such as "How Yukong Moved the Mountain," a traditional tale that was a favorite of Mao Tse-Tung, and instructions for divining a person's fate from his or her facial features.[1] Made two years after he immigrated to America, this work reflects the artist's ongoing quest to symbolize – often using his body as a primary material – his own struggles as well as the challenges others have faced in a rapidly changing China.

Born in Henan province and reared in a rural village, Zhang Huan grew up in poverty, and he saw members of his family suffer and die. Although he was a poor student, Zhang Huan could draw. He won a place in an art program that trained him in Soviet and European painting styles. Transferring to the prestigious Central Academy of Fine Arts in Beijing in 1991, he began discovering his distinctive style. One day, he tried using the bottom half of a broken plastic mannequin to walk with three legs. This bizarre experiment led him to a key understanding:

I have always had troubles in my life. And these troubles often ended up in physical conflicts. . . . All of these troubles happened to my body. This frequent body contact made me realize the very fact that the body is the only direct way through which I come to know society and society comes to know me.[2]

51 **Family Tree**
2000 (printed 2003)
Nine chromogenic prints on paper
48 × 38 in. each
Museum Purchase, 2003.0022.a–i

Zhang Huan abandoned easel painting and began creating performance-based works, a number of which symbolically addressed social conditions in China. For example, *12 Square Meters* (1994), in which the honey- and fish oil-covered artist sat for an hour in a fly-infested public latrine, and photographs such as *To Add One Meter to an Anonymous Mountain* (1995), depicting naked bodies piled on a hilltop, symbolized the subordination of the individual to the collective. Other works derived from his experiences as a foreigner. For the hourlong *Pilgrimage – Wind and Water in New York* (1997), he lay naked and face down on a block of ice in the courtyard of a Long Island City museum, surrounded by dogs; he explained that the piece stemmed from his difficulties adjusting to America, where pets are often received more warmly than new immigrants.

Family Tree dramatizes how Zhang Huan's interior life has been stamped by the stories passed on to him by his family, peers, and homeland. His accomplishment has been to recognize this second skin of conditioning and to slip in and out of it to make art that is both personal and universal.

Toby Kamps

1. Zhang Huan in www.zhanghuan.com/ShowWorkContent.asp?id=27&iParentID=18&mid=1. Accessed September 13, 2009.

2. Zhang Huan quoted in Qian Zhijian, "Performing Bodies: Zhang Huan, Ma Liuming, and Performance Art in China," *Art Journal* 58, no. 2 (Summer 1999): 63.

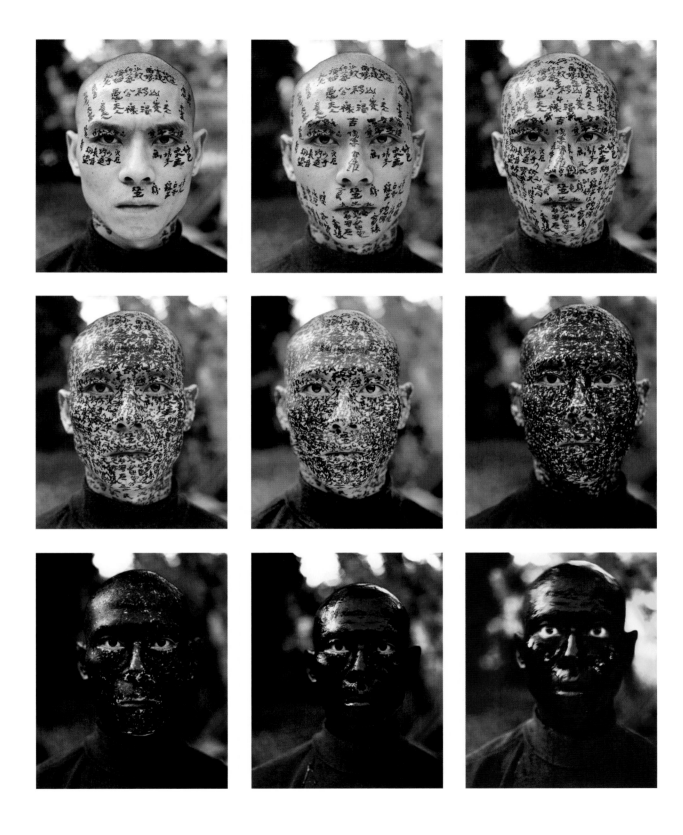

Christoph Morlinghaus (German, born 1968)

52 *TWA (Bridge)*

2004
Chromogenic print on paper on Sintra
71 1/2 x 85 3/4 in. (sheet); 58 1/8 x 73 1/4 in. (image)
Museum Purchase, 2005.0003

WHEN EERO SAARINEN RECEIVED THE COMMISSION TO DESIGN THE TRANS WORLD AIRLINES (TWA) TERMINAL AT NEW YORK'S IDYLWILD (now John F. Kennedy International) Airport in 1956, he was asked to create a building that would, in his words, express "the drama and specialness and excitement of travel."[1] He succeeded. Completed in 1962, a year after the architect's death, it remains both an icon of modern architecture and the supreme architectural embodiment of the idea of flight. Ironically, however, what was once a marvel of contemporary design has now become an embattled relic, occupying the oxymoronic category of "modern antique." Although it is on the National Register of Historic Places, the building ceased operating as a terminal in 2001 and is at the center of a continuing controversy over how best to preserve and use it. (In 2005, after modifications, one section was incorporated as part of a new terminal.)

The interior of the TWA terminal, described by the architect Robert A. M. Stern as the "Grand Central of the jet age," is a space of steel, concrete, and glass, the primary materials of modern architecture.[2] It seems, therefore, aptly recorded by the modern medium of photography. Architectural photography is often overlooked – except, of course, by architects. It is no easy matter to catch three dimensions in two, to create a sense of space and place by capturing something of the physical, not just visual, experience of a building.

Christoph Morlinghaus, who started out as a still-life photographer, brings to his architectural images a keen sense of composition, form, color, and light. His rendering of the TWA terminal's great central space has a subdued tone. Working with traditional photographic film, Morlinghaus relies only on natural light and on the illumination provided by the building's indirect artificial lighting. (He does not introduce additional lights of his own or use digital manipulation after the fact.) The vantage point beautifully serves the complexity and drama of Saarinen's design: the symmetry of the domelike ceiling forms is set against the asymmetry and almost baroque curves of the shapes beneath, just as the strength of the unadorned, sculptural concrete surfaces is offset by the delicate railing that frames the gallery-level bridge.

From his very first architectural project, a study of the abandoned Frankfurt headquarters of the once-gigantic IG Farben chemical company, Morlinghaus has been fascinated by the tension between the forward-looking character of modernism and the now-retrospective aspect of the surviving buildings. Although his photographs usually suggest a calm and deliberate gaze, this particular image, showing a vast public area devoid of people, feels rather disturbing, even spooky. It is as if the clock suspended in the center of the image has been stopped – not by the photographic process but by time itself, standing still as the building awaits its fate.

Robert Silberman

1. Aline B. Saarinen, ed., *Eero Saarinen on His Work*, rev. ed. (New Haven and London: Yale University Press, 1968), 68.

2. Stern quoted in Herbert Muschamp, "Architecture View: Stay of Execution for a Dazzling Airline Terminal," *New York Times*, November 6, 1994.

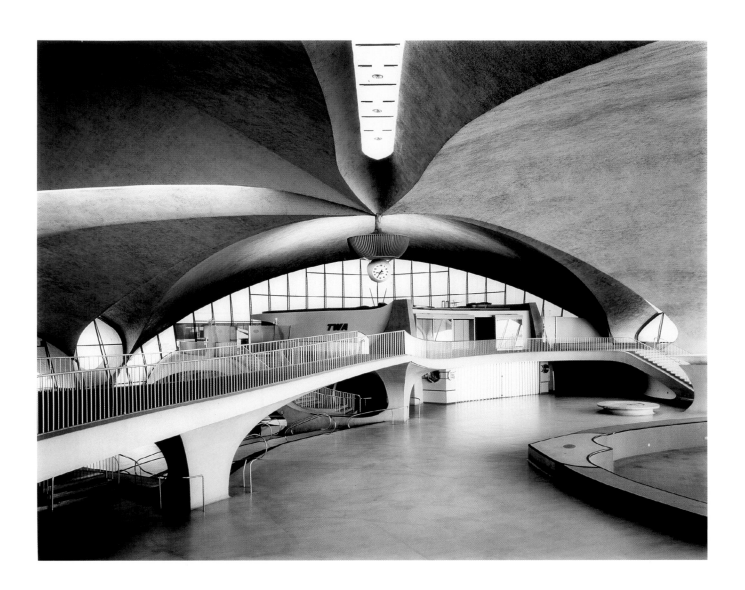

IN THE MID-1990S, WHEN KARA WALKER REVIVED THE QUAINT MEDIUM OF CUT-PAPER SILHOUETTES, the no-holds-barred contemporary-art world was preoccupied with the dynamics of racial, sexual, and political power.[1] She employed deftly scissored figures as characters in room-scale narrative tableaux, as shadow puppets in stop-action films, and as subversive commentaries upon historic illustrations of the Civil War – all offering wildly absurd, alternate histories of African Americans. Filled with caricatured images of slaves, masters, lynching, rape, and bestiality, Walker's work played fast and loose with stereotypes and violence, leaving few feathers unruffled. It offended an older generation of black artists for seeming to reaffirm white racism, and it offended a post–civil rights-movement generation for offering no escape from self-loathing. Walker is aware of these criticisms but views as fraught the very act of depicting African Americans. "Every image of 'us' is mediated," she writes on an illustrated diary page, "filtered through the grounds of years of misrepresentation, bitterness, and suspicion."[2]

In the lithograph *I'll Be a Monkey's Uncle*, Walker opens the Pandora's box of American racist iconography with typical fearlessness. Depicting on the left an archetypal pickaninny – a young black girl with unkempt hair, ragged clothes, and bare feet – and a long-tailed monkey in male clothing standing on a stump on the right, the work is rife with charged allusions. The monkey's tail loops forward to become a phallus pointing at the girl, and the dripping do-rag, hair braid, or disembodied tail held aloft by the girl suggests amputation, castration, or possibly even the scalping of a white woman for her desirable, straight "good hair." The work's title also conjures up false associations of people of African descent with apes and a lower rung on the evolutionary ladder.

53 *I'll Be a Monkey's Uncle*
1996
Lithograph on paper, 39 3/4 x 35 in.
Museum Purchase, 2001.0017

Walker discovered that the very flatness and emptiness of the silhouette medium provided a powerful vehicle for traversing the minefield of racial representation:

> I had a catharsis looking at early American varieties of silhouette cuttings. . . . What I recognized, besides narrative and historicity and racism, was this very physical displace-ment: the paradox of removing a form from a blank surface that in turn creates a black hole. I was struck by the irony of so many of my concerns being addressed: blank/ black, hole/whole, shadow/substance, etc.[3]

I'll Be a Monkey's Uncle may be open-ended, offering little resolution for age-old problems. But the work's black humor and black imagery, along with its title – a common expression of consternation – provocatively remind us of the urgent need to evolve beyond our exasperating and poisonous fixations on race.

Toby Kamps

1. The present entry builds on ideas and research the author developed in *The Old, Weird America*, exh. cat. (Houston: Museum of Contemporary Arts Houston, 2008), which surveys the resurgence of folk themes in contemporary American art.

2. Walker diary page quoted in Ariella Budick, "Review: Kara Walker at the Whitney Museum," *Newsday*, October 13, 2007. Available online at www.newsday.com/entertainment/fanfare/rage-black-and-bleak-1.644776. Accessed October 9, 2009.

3. Walker quoted in Hilton Als, "The Shadow Act," *New Yorker* 83, no. 30 (October 8, 2007): 75.

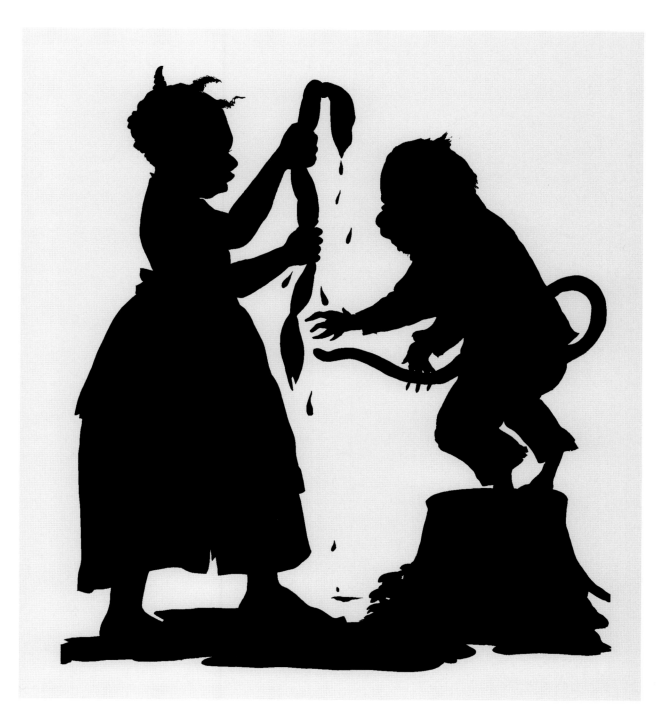

VIBRANT COLORS AND HYPNOTIC RHYTHMS CHARACTERIZE WHAT JEREMY BLAKE CALLED HIS "TIME-BASED PAINTINGS," digital animations whose shapes morph and mutate in translucent layers. He began making these works in the 1990s, drawing upon his training as an abstract painter, his knowledge of twentieth-century art and architectural history, and his fascination with popular culture. Although highly abstract, the animations are often rooted in uncanny narratives, both real and fictional, taken from artists' biographies, popular contemporary legends, and Blake's own imagination. The artist did not tell these stories outright but instead hinted at them with carefully chosen sounds and images. In a 2001 interview about *Mod Lang*, he explained: "I am interested in the fact that narrative cues, such as suspenseful noises, are extremely disorienting when used in a largely abstract, time-based artwork. . . . It's important to me that the threat of a narrative intrusion transforms the work."[1]

Mod Lang was first the title of a larger installation that included two other digital animations, three chromogenic prints, and a set of ten drawings that provided a sort of storyboard for the show. There, the drawings told Blake's story of a teenage hipster, Keith ("Slick") Rhoades, who wrecks his motor scooter on a rainy London street one night. Believed to have suffered brain damage due to the accident, Rhoades razes a historic castle and in its place erects a home for stylish vampires. This leads him to be banished from England and sent to southern California, where he lives happily in exile. The three projected animations, on a separate wall from the drawings, were loosely related to the story. In the title animation, *Mod Lang*, sliding doors part to reveal what might be a hallucinogenic image of the slick street on which Rhoades crashed. Rivulets of rich, viscous hues stream down the screen — expanding, contracting, overlapping, and merging into one another.

54 *Mod Lang*
2001
Digital animation, dimensions variable
Museum Purchase, 2002.0028

These streams of color evoke the mid-twentieth-century paintings of Helen Frankenthaler and Morris Louis, who explored the possibilities of color saturation by pouring paint onto unprimed canvases. The influential critic Clement Greenberg championed these color-field artists, whose work represented his ideal of modern painting, which was that it should simply be about the application of paint to a flat surface. Blake consciously referenced the color-field paintings but also purposely linked them to a story and, by setting them in a continuous animated loop, created the illusion that their flow is perpetual.

Blake's approach to his art — at once serious and lighthearted — is succinctly conveyed in his explanation of the title *Mod Lang*, which originally was the title of a song by the Memphis rock band Big Star:

> To me, "Mod Lang" calls up a nice range of possible interpretations. It could be short for something as high-minded as "modernist language," or it could be "languid mods," maybe after a group of young people who are blissfully wiped out after being up for 48 hours.[2]

Emily Stamey

1. Blake interviewed by Tim Griffin, "H-h-h-his Generation: Jeremy Blake Remakes Mod at the Turn of the Millennium," *Time Out New York*, October 18–25, 2001: 76.

2. Blake quoted in Sarah Valdez, "Attack of the Abstract," *Art in America* 90, no. 3 (March 2002): 104–5.

Jules de Balincourt (French, born 1972; active Brooklyn, New York)

55 *The Watchtower*
2005
Oil, enamel, and spray paint on plywood
panel, 31 x 38 7/8 in.
Museum Purchase, 2005.0008

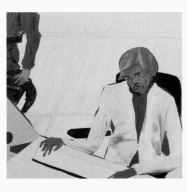

BEHOLD THE
STRANGE SOLAR
SYSTEM, the white-hot
center of commerce
and industry, blue and
red planets orbiting
and adhering, tiny
spots illuminated only
by reflected glow. Each
planet with its own
revolving circumstance, orbit, moon(s), light, and dark. In
the distance, dwarfs and satellites and black holes. Space the
endless black beyond.

What fuels this source of heat? This obliterating force that
diminishes all that surrounds it? Its throb is a reminder of
unceasing power, god of watchfulness, overlord of darkness,
smiter of lesser beings.

We made God when we needed an explanation. We trusted
science when we had questions outside the Father's purview.
But what in us has demanded The Watchtower? And when
will we, finally, be relegated to the outlying areas of the big
picture?

Antonya Nelson

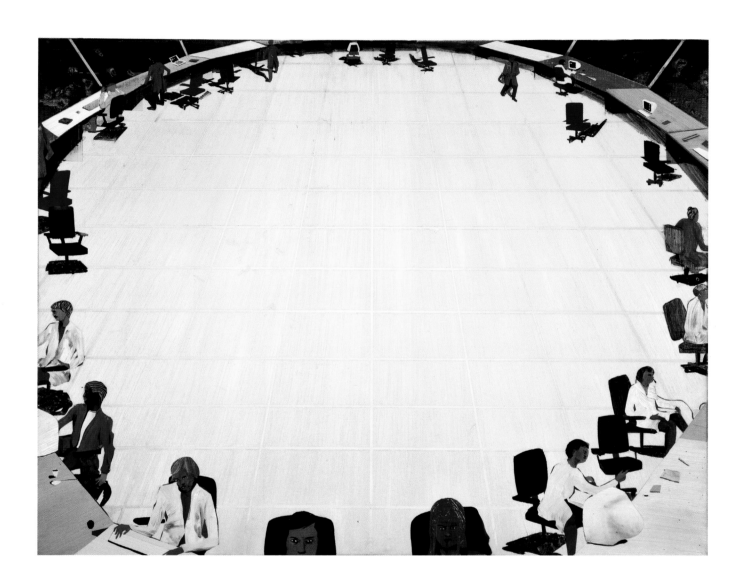

RADCLIFFE BAILEY'S DENSE MULTIMEDIA WORKS INTERWEAVE NARRATIVE FRAGMENTS OF AFRICAN AMERICAN HISTORY with the artist's own experiences as a black man. Typically, he creates a complex layering of painted marks, written words, photographs, found objects, glitter, dirt, and resin to form an associative collage. Bailey likens his improvisational method to practicing and performing jazz. Producing several works simultaneously, he builds a layer on one and then moves on to others before returning to add the next layer. Balancing quick and slower tempos, he allows for both spontaneity and reflection.

In 1999 Bailey completed seven untitled eighty-by-eighty-by-five-inch works mounted on wooden panels; they are collectively known as the Kindred series. Each panel holds a centralized photograph culled from Bailey's grandmother's collection of family tintypes and from his own images of African sculptures. Set into the panel behind a sheet of Plexiglas, these photographs are surrounded by the artist's signature web of painted and collaged elements. Each piece in the series honors a different aspect of African American history.

The Ulrich Museum commissioned Bailey to create a similar work, this one honoring the history of African Americans in Kansas. After doing research at the Kansas African American Museum in Wichita, he produced *Exodus*. Like works in the Kindred series, this one is richly inlaid with symbols both historically and personally specific.

Across the wide border of *Exodus*, a complex network of meandering lines recalls branches, roots, rivers, and roads as they weave over and under rectangular patches that suggest quilt blocks and plots of land. The title is contained in a patch at the lower left, and the date 1879 appears at the upper right. Together these elements refer to the so-called Exodus of 1879, when some six thousand African Americans fled white oppression in the South. Many of them settled in Kansas, encouraged by the Homestead Act of 1862, which offered individuals titles to parcels of undeveloped land for farming, and by the state's legacy as a pre–Civil War bastion of the anti-slavery movement. The photograph at the center is an enlarged vintage image of men who might well have been descendents of people who arrived in 1879: African American members of the Wichita YMCA Orchestra and Glee Club.

56 *Exodus*
2002
Resin, acrylic, clay, photographs, and Plexiglas on wood, 80 x 80 x 4 in.
Museum Purchase, 2002.0018

Bailey's choice of photograph acknowledges both the significant role music has played in African American history and the artist's own relationship to that history and to music itself. In other works, he has paid tribute to jazz legends Duke Ellington and Charlie Parker. Of his own visually syncopated style, he has frequently said, "What I do may not even be called art. It may be called music."[1] Other facets of *Exodus* are personally meaningful, too: the pale green color repeated across the panel refers to Bailey's grandfather's favorite room, and the butterfly is a loving nod to the artist's young daughter.[2] By incorporating personal symbols in a painting about Kansas, Bailey, who lives in Georgia, recognizes his connection to a larger historical narrative and celebrates culture's evolution from an amalgam of both individual and collective stories.

Emily Stamey

1. Bailey quoted in Mason Klein, "Radcliffe Bailey at Jack Shainman Gallery," *Artforum* 38, no. 6 (February 2000): 121.

2. Terrie Sultan, "Rhapsody in Orange," in *Radcliffe Bailey: The Magic City*, exh. cat. (Birmingham, Ala.: Birmingham Museum of Art, 2001), 26–27.

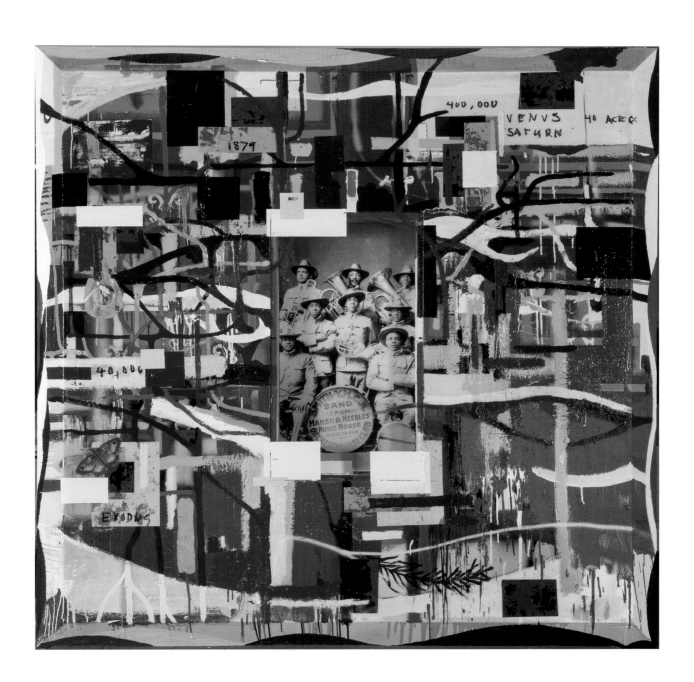

Dana Schutz (American, born 1976)

57 *Missing Link Finds Superman*
2006
Oil on canvas, 71 3/4 x 60 1/2 in.
Museum Purchase, 2007.0014

AT THE END OF THE WESTERN WORLD A MOUNTAIN RISES, filled with the detritus of indulgence and boredom, ignorance and primary-colored candy. Kitchen appliances. Halloween costumes. Pale creatures patrol the heap in search of the valuable, the knowable, the useful, and the instructive. They have been sheltered from the Sun, unbaked beings with Moon-toned flesh. They stare at the world with the flat intensity of television.

What heroics might the white boy perform? Sloped shoulders, blank forehead, cherry lips, and absent chin? Groomed as if for military service, standing atop his pile of tidy trash – no swarming flies, no toxic waste, no sludge or blood or fecal matter – he dons pajamas as his uniform, as if to take part in his own two-dimensional comic-strip dream, unarmed, undaunted, innocent as a baby, crawling with a toothless smile, right into the Kryptonite.

Antonya Nelson

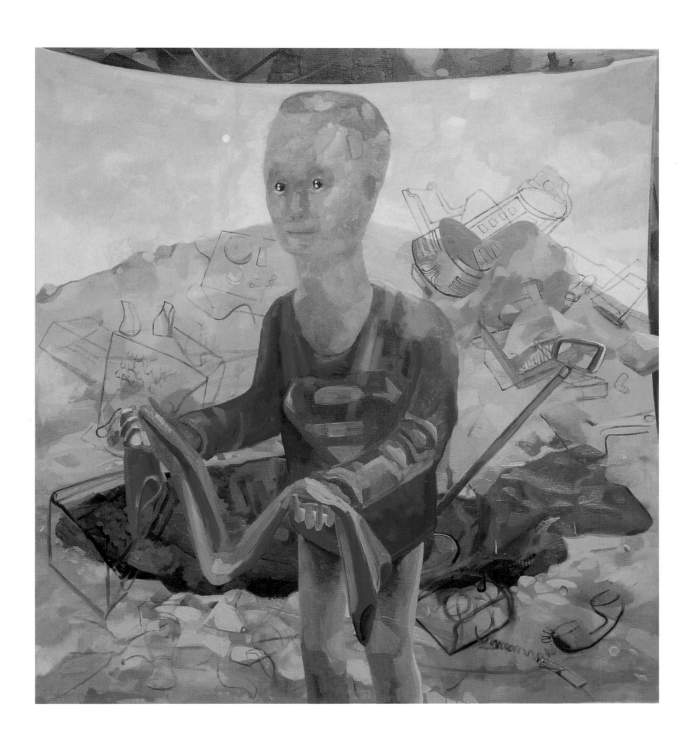

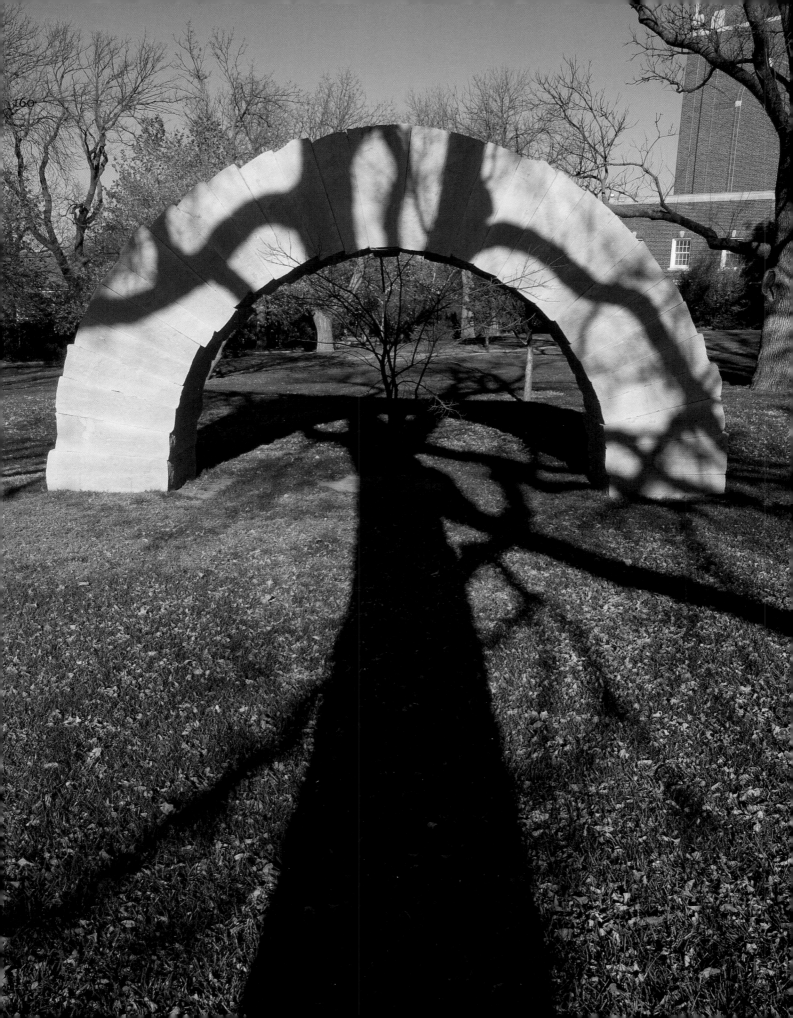

Sponsors

This exhibition and book have been made possible through the generous support of
Emprise Bank
National Endowment for the Arts

Additional sponsors include:
Joan S. Beren Foundation
Edward and Helen Healy
Harry Pollak
Richard S. Smith and Sondra M. Langel

Support has also been provided by:
Jon and Kelly Callen
Mike and Dee Michaelis
Jayne S. Milburn
Christine F. Paulsen-Polk
Wichita State University Office of the Provost
 and Vice President for Academic Affairs
 and Research

Demonstrating their support for *Art of Our Time*, a number of patrons contributed funds for the curatorial care of works in the Ulrich collection that are featured in this exhibition and book. Those patrons are acknowledged here, along with the artworks they sponsored.

An anonymous patron sponsored W. Eugene Smith's *Frontline Soldier with Canteen, Saipan*, Claes Oldenburg's *Inverted Q, Trial Proof (White)*, and Edward Weston's *Pepper*.

Mickey Armstrong sponsored W. Eugene Smith's *The Walk to Paradise Garden*, in memory of Pete Armstrong, a friend of Gene Smith.

Marcia and Ted D. Ayres sponsored Luis Alfonso Jimenez's *Sodbuster: San Isidro*.

Martin and Ann Bauer sponsored George L. K. Morris's *Unequal Forces, No. 2*.

Shirley and Donald Beggs sponsored Childe Hassam's *Distant Valley, Montauk*, in honor of the Ulrich Museum staff.

Louise R. Beren sponsored Andy Warhol's *Chicken 'n Dumplings*, in honor of S. O. (Bud) Beren.

Joan S. Beren sponsored Joan Miró's *Personnages Oiseaux* (Bird People) and Robert Indiana's *LOVE*.

Ralph and Alta Brock sponsored Audrey Flack's *Cover Girl*.

Jon and Kelly Callen sponsored Peter Sarkisian's *Dusted*.

Eric Engstrom and Robert Bell sponsored Milton Avery's *Boats in Yellow Sea*.

Dr. Alan and Sharon Fearey sponsored Robert Henri's *Gregorita with the Santa Clara Bowl*.

Advisory Board and Staff

About the Contributors

Toby Kamps is senior curator at the Contemporary Arts Museum, Houston. He has organized exhibitions on the work of Vanessa Beecroft, Ellsworth Kelly, and Claes Oldenburg as well as such themed exhibitions as *Small World: Dioramas in Contemporary Art* (2000), *Lateral Thinking: The Art of the 1990s* (2002), and *The Old, Weird America* (2008).

Patricia McDonnell is director of the Ulrich Museum of Art. Her scholarly focus is upon European and American modernism, and she is a leading specialist on the painter Marsden Hartley. Her publications include *Marsden Hartley: American Modern* (1997), *On the Edge of Your Seat: Popular Theater and Film in Early Twentieth-Century American Art* (2002), and *Painting Berlin Stories* (2003).

Laura Moriarty is the author of three novels and the recipient of several literary awards. Before becoming a full-time writer, she was a social worker. Moriarty lives in Lawrence, Kansas, where she teaches creative writing at the University of Kansas.

Antonya Nelson has written three novels and published six short-story collections. She contributes often to the *New Yorker* and the *New York Times Book Review*. Nelson holds the Cullen Chair in Creative Writing at the University of Houston. Her award-winning novel, *Living to Tell* (2000), takes place in her hometown of Wichita, and her forthcoming novel, *Bound*, is set there as well.

Timothy R. Rodgers is director of the Scottsdale (Arizona) Museum of Contemporary Art. Formerly chief curator at the New Mexico Museum of Art, Santa Fe, he is involved in a range of writing and curatorial projects. His scholarly concentration is on American early modernism.

Robert Silberman is an associate professor of art history at the University of Minnesota's Twin Cities campus. His chief scholarly interests have been photography, film, and contemporary art. Silberman collaborated with former *New York Times* photography critic Vicki Goldberg on the companion volume for the 1999 PBS series *American Photography: A Century of Images*.

Larry Schwarm is a professor of art at Emporia State University, Emporia, Kansas, and a nationally regarded photographer whose work has been shown at the Art Institute of Chicago and the Smithsonian American Art Museum, Washington, D.C. His 2003 book, *On Fire: Larry Schwarm*, won the Honickman Book Award and Prize.

Emily Stamey, the Ulrich Museum's curator of modern and contemporary art, is the author of *Jolán Gross-Bettelheim: The American Prints* (2001) and *The Prints of Roger Shimomura: A Catalogue Raisonné, 1968–2005* (2006). Her scholarship centers on ethnic identities and social themes in American art.

Justus Fugate sponsored Margaret Bourke-White's *NBC Radio – Microphone*, in memory of Connie Thomas Arnold.

Ann E. Garvey sponsored Gordon Parks's *Muhammad Ali on Staircase*.

Bud and Toni Gates sponsored Jules de Balincourt's *The Watchtower*.

Diana and Jeff Gordon sponsored Nan Goldin's *Picnic on the Esplanade, Boston,* in honor of Wichita's dedicated arts patrons.

Sonia Greteman and Chris Brunner sponsored Diane Arbus's *Lady Bartender at Home with a Souvenir Dog, New Orleans*, in honor of their friends at Planet Hair.

The R. C. Kemper Charitable Trust, UMB Bank, n.a., Corporate Trustee sponsored Zhang Huan's *Family Tree*.

Elizabeth and Don King sponsored Alexander Calder's *The Big Wheel*.

Dr. Sam and Jacque Kouri sponsored Tom Otterness's *Millipede*.

Tom and Nancy Martin sponsored Frederick Judd Waugh's *Peasant Landscape*.

Dr. Patricia McDonnell sponsored Eugène Atget's *Marchand de vin, 15 rue Boyer* (Wine Seller, 15 rue Boyer).

Jane McHugh sponsored Joan Miró's *Signes et Symboles* (Signs and Symbols).

Dr. Rodney Miller and Dr. Pina Mozzani sponsored Charles Grafly's *Pioneer Mother*.

The Victor Murdock Foundation sponsored Joan Mitchell's *Untitled*.

George M. Platt sponsored Frank Lloyd Wright and George M. Niedecken's *Henry J. Allen House Dining Set*.

Beverly and James J. Rhatigan sponsored Jeremy Blake's *Mod Lang*.

Scott and Carol Ritchie sponsored Robert Motherwell's *Study in Automatism*.

Bruce and Linda Schreck sponsored Emil Nolde's *Daisies and Peonies*.

Shoko Kato Sevart sponsored Andy Goldsworthy's *Torn Leaf Line Held to Fallen Elm with Water, November 15, 2002*.

Martha and Kent Shawver sponsored Emil Carlsen's *Barnacled Rocks*.

Southwest National Bank sponsored Imogen Cunningham's *Clare and Floating Seeds*.

Ron and Lee Starkel sponsored Louise Nevelson's *Moving-Static-Moving-Figure*.

Keith and Georgia Stevens sponsored Dorothy Dehner's *Arcanorum* and Christoph Morlinghaus's *TWA (Bridge)*.

James and Ann Townsend sponsored Helen Frankenthaler's *Wind Directions*.

Mrs. Dwane L. Wallace sponsored Frank Duveneck's *Portrait of a Lady*.

The Lois Kay Walls Foundation sponsored Andy Goldsworthy's *Wichita Arch*.

The Wilson Foundation sponsored Robert Motherwell's *Les Caves No. 2* (The Cellars No. 2).

Reproduction Credits